Atlanta's PONCE DE LEON AVENUE

A HISTORY

SHARON FOSTER JONES

THE
History
PRESS

Published by The History Press
Charleston, SC 29403
www.historypress.net

Copyright © 2012 by Sharon Foster Jones
All rights reserved

Back cover, painting by Shannon Goines.
All images are from the author's collection unless otherwise noted.

First published 2012
Second printing 2013

Manufactured in the United States

ISBN 978.1.60949.349.3

Library of Congress Cataloging-in-Publication Data
Jones, Sharon Foster.
Atlanta's Ponce de Leon Avenue : a history / Sharon Foster Jones.
p. cm.
Includes bibliographical references and index.
ISBN 978-1-60949-349-3
1. Ponce de Leon Avenue (Atlanta, Ga.)--History. 2. Atlanta (Ga.)--History. 3.
Atlanta (Ga.)--Social life and customs. 4. Atlanta (Ga.)--Biography. I. Title.
F294.A875P664 2012
975.8'231--dc23
2011050623

To my husband, Craig T. Jones, for his advice when I didn't know how to begin this book: "Write about the parts of Ponce that interest you first, and the rest will follow."

CONTENTS

ACKNOWLEDGEMENTS

I am very grateful to my "history friends" for their interest, support and nuggets of information. In particular, Jeff Clemmons has been a relentless cheerleader and took time away from writing his own book to research bits of history for me. Joe Morris unknowingly inspired the chapter names when he let me scan his Ponce de Leon Park postcard for this book. The folks at the Atlanta Preservation Center—Carolyn Stine McLaughlin and Paul Hammock—have supported the idea of a Ponce history book from its inception. Joseph Gatins, a living piece of history himself, shared his memories of Ponce and the Georgian Terrace. Kit Sutherland had no qualms about walking Ponce de Leon Avenue with me (and a few prostitutes) to get up close and personal with Ponce's history. Andrew Wood has a frightening amount of Ponce history in his head and willingly shared it as soon as he heard I could use it, and Tommy Jones made his wealth of knowledge available. Jeff Holt has enriched my life with his music and has enriched this book by telling me where the cool people party on Ponce. My friends on the "Pontificating on Ponce" Facebook page supplied me with invaluable pieces of information and laughs and reminded me there are lots of people out there who enjoy Atlanta's history as much as I do.

Many thanks to Kenneth Wideman for his Druid Hills Presbyterian Church history, to Ben Ruder for letting me get a behind-the-scenes look at the Plaza Theatre and to Father John Azar (a history buff as well as a spiritual leader) for giving me a thoughtful tour of St. John Chrysostom Melkite Catholic Church. The guys at Atlanta Eagle—specifically, Robert

Kelley and Jack Rogers—immediately opened their doors to me, and Leonard Goodelman (who is following his father's footsteps in photography at Affordable Photography in Alpharetta) told me all about his dad and the Kodak building on Ponce. I appreciate the thoughts and information from Kevin Burke at the Atlanta Beltline, Angel Poventud, Regina Brewer, Myrna Lance, Charles Bearden, Oreon Mann and Ellen Johnston at Georgia State University.

Being a native Atlantan myself, I felt free to call upon my family for their memories of Ponce de Leon Avenue. Thank you to Franklin H. Foster Sr. (Dad), who first told me about a little place called the Pig'n Whistle, and his siblings, Charis Perry, Steven Foster and Renee Grimes, for their stories about their mother and my grandmother, Ida Lucile Foster, who worked at Colonial Stores in Briarcliff Plaza to support four children. My sister, Virginia "Ginny" King, added a little information to the pot and listened to me whine for a year.

It has been a pleasure to work with all of you to pull a history of Ponce de Leon Avenue together, and I hope you like it. Thank you!

INTRODUCTION

Juan Ponce de Leon went in search of the River Jordan, that he might have some enterprise on foot, or that he might earn greater fame than he already possessed… or that he might become young from bathing in such a stream.
—Memoir of Don Hernando d'Escalante de Fontaneda, *respecting Florida, 1575*

The legend of Juan Ponce de Leon and the Fountain of Youth came from those words—a simple story of hope, written in the memoir of a sixteenth-century Spanish man who had been marooned in Florida as a boy. Like the legend of the mythological fountain, Ponce de Leon Avenue in Atlanta, Georgia, was founded on the promise of power gained through flowing water.

Healing springs once drew early inhabitants to drink mineral waters that trickled from rocks at the base of a hillside a few miles from the area that would become Atlanta. Because of their medicinal qualities, the springs were named for the famous Spanish explorer, and the street that led to the springs also began to bear his name. Antebellum families situated their plantations around the area that later became Ponce de Leon Avenue (pronounced by locals in the non-Spanish way of "pän(t)-s di lE'än"). And after the Civil War, the citizens of downtown Atlanta traveled by wagons, mule-drawn trolleys and, eventually, electric-powered streetcars, forging a rough road through the virgin forest from Peachtree Street to the springs.

A Ponce de Leon Avenue address became a source of pride for the Victorian homeowners of Atlanta and continued to be an elite address through the first part of the twentieth century. But the world changed, trolleys gave way to automobiles and the people moved away from the inner city. In place of the mansions that once lined the street came apartment buildings and businesses. The fashionable avenue became a highway—a mere corridor—from Atlanta to Decatur, Georgia.

Don Hernando's words "enterprise" and "fame" are redolent of this broad road, along with a host of other words such as home, homeless, stylish, seedy, resplendent, naked, thronging, lonely and stately. Today, Ponce de Leon Avenue is casually referred to as "Ponce" by the local residents. That name brings to Atlantans' minds a kaleidoscope of treasured memories, architectural antiques, new condominiums, fast-food restaurants and human depravity—all caught in the rear-view windows of the thirty thousand motor vehicles that daily travel the street. Ponce claims the people of its city; they depend on it, take it for granted, are blinded to its beauty. From the spires of its historic churches piercing through pure skies to the drug deals in its littered parking lots, Ponce is as familiar to Atlantans as a comfortable old shoe—a fine-quality shoe, but nonetheless, one with a few holes in its sole. This book is not intended to be a complete history of every person and every structure that has ever lined the ninety-foot-wide street but, rather, a chance for the city to slow down and get a glimpse of what once was, what still is and what may one day be again on Ponce de Leon Avenue.

Chapter 1

AS MUCH GROUND AS THERE EVER WAS

THE ANTEBELLUM YEARS

Atlanta's main street, Peachtree Street, was carved through Creek Indian country during the War of 1812. Three strong men struck out from Fort Daniel in Gwinnett County, chopping through woods and weeds, over hills and through marshy valleys, until they reached Fort Peachtree in what is now western Atlanta. They came by way of Ponce de Leon Avenue, which was nothing but tree-covered hills and spring-filled valleys in those days. The leader of the three road builders was Robert Young from Hall County, known for his ever-present ponytail and common sense. Making it through the wilderness of Georgia's piedmont was a feat alone, but combining that with warring Native Americans, and even working alongside them, was miraculous. Upon reaching Fort Peachtree, the men hired helpers, turned around and built a road back from whence they had come. On a building erected nearly directly over the original Ponce de Leon Springs is a bronze plaque placed there by a local chapter of the Daughters of the American Revolution in 1935, thus marking the spot of Ponce de Leon Avenue's first recorded travelers. It reads as follows:

> *This tablet*
> *Commemorates the spot,*

Formerly Ponce de Leon Spring,
Where Robert Young,
A Revolutionary Soldier,
Of Cherokee, now Hall County,
First Traded with the Creek Indians,
And built the Peachtree Trail from
Atlanta to Flowery Branch.

A few years after the original Peachtree Road was built, pioneering families began to farm the region that later became Ponce de Leon Avenue in Atlanta. Two families controlled most of the land: the Todds and the Medlocks. Richard Copeland Todd (1792–1852) bought Land Lot Seventeen (202.5 acres) in 1822 for $100, which included the land running from today's Virginia-Highland neighborhood to North Avenue. He built a house on the northern end of the lot and commenced farming and rearing a family with his wife, Martha Todd (1802–1896). They had at least six children. Todd's lot contained the particular pair of springs that were later named Ponce de Leon Springs—the spot where, in 1926, the Sears, Roebuck Company built a massive brick building that stands today. The Todds were connected to Atlanta's first known settler of the downtown area, Hardy Ivy, who was married to Richard Todd's sister, and the families created a road between the Ivys' and the Todds' houses known as Todd Road. A part of Todd Road still exists today near Ponce. Although there is no definitive proof, the absence of records to the contrary indicates that the Todds did not use slave labor on their farm. The Todd family remained in the Ponce area for decades, selling off most of their land as Atlanta's development progressed throughout the Ponce area in the twentieth century.

The Todd graveyard still survives in Land Lot Seventeen in an area now located in the neighborhood of Virginia-Highland. The cemetery—four-tenths of an acre—was deeded to the City of Atlanta in 1934 as part of a litigation agreement; the Todd heirs had feuded with the city in court over the disposition of the graveyard. Allegedly, a dozen bodies are buried in the tract, but only Richard's and Martha Todd's graves are marked. Their daughter, Patience Elizabeth Todd (1827–1900), married John M. Armistead (1827–1908); both are buried at Peachtree Baptist Cemetery on Briarcliff Road in northeast Atlanta.

John Williams Medlock (1803–1882) hailed from Gwinnett County, Georgia, buying Land Lot Forty-eight in the late 1840s. He and his wife, Sarah Jemison Ware Medlock (1807–1883), farmed their land around

Ponce de Leon Avenue with their eleven children, all of whom were born in Gwinnett County. (The Medlocks had two more children after they moved to the Ponce area in Atlanta; both died in infancy.) They made their home near a spring on land that is now near Grace United Methodist Church on Ponce de Leon Avenue. The Medlocks did make use of slave labor, but they were not the stereotypical plantation owners of hundreds of slaves in the antebellum South; they reported six slaves in Atlanta in 1850 between the ages of one and thirty-one years and ten slaves in 1860 between the ages of four months and forty-four years.

The Civil War devastated the city in the summer of 1864 when the Northern armies, led by General William T. Sherman, came through Georgia on their way to the sea and took Atlanta. There was fighting on the antebellum farms of Ponce; forts were built, breastworks dug and foliage removed. The families abandoned their farms and fled Atlanta, returning to the ruined land after the war had ended. Four Medlock sons fought for the Confederacy—Thomas, John, William and Eli. Thomas committed suicide shortly after his return from war, his mental injuries being greater than his physical ones. In 1866, Sarah Medlock wrote her daughter Martha, who had moved to Texas, about the family's war experiences, and her letter, though somewhat coarsely written, describes the Medlock family's circumstances resulting from the battles around today's Ponce de Leon Avenue. Her matter-of-fact tone belies the pain she must have felt:

We left home in July '64 the 12th day. We left our furniture. We took a few chairs and bedding, the best or the most of our clothes—the cattle we sold to the government except three cows and calves. We have one cow and calf is all the stock except two mules. We lost our hogs and horses. We refugeed at Washington County, stayed there September '64 until November '65. The fighting was mostly from Peachtree Road around to Decatur. Our houses burned, our timber cut down on the home lot, our shade trees and pretty well all of our fruit trees.

There has been thousands of pounds of lead picked up on our land. People supported their family picking up lead. They got 50 cents a pound before the surrender. The bomb-shells is plenty, many with the load in them...

About the boys, they are all home except Thomas, poor fellow—his body lies in the nearest grave yard to his house—he shot his brains out. He was wounded in the 7 days fight before Richmond in '62—shot himself in '64. He never enjoyed life after he was wounded. John came home unhurt, only

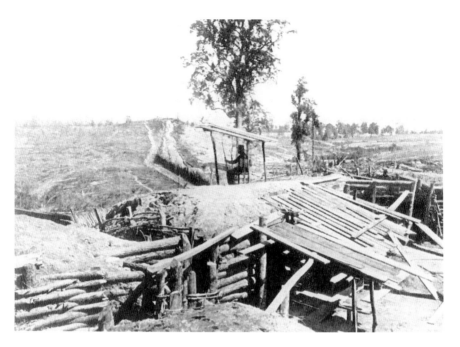

During the summer of 1864, Confederate Fort K was located near the intersection of Ponce de Leon Avenue and Peachtree Street.

his constitution somewhat impaired. W.P. [William] badly hurt, has lost his left hand and fore-finger on his right hand, neither amputated. E.W. [Eli] is living in Troop County. Was wounded at Sharpsburg, hurt badly but has, I learn, got over it. I have not seen him since the surrender...

You seem to think of coming back to Atlanta, there is as much ground here as there ever was, but not as many trees.

And so the families of antebellum Ponce de Leon Avenue put their houses and families back together after the Civil War and started a new era on Ponce—a life without slave labor, a life that would set the stage for the day when the town of Atlanta, just two miles away, reached out to Ponce and beheld it as a place of beauty. In 1883—the year following John Williams Medlock's death—three hundred acres of his land near Ponce was auctioned for development; it had been divided into fifty lots. About 1890, when the Medlock land began to be platted for residential development, the Medlock family's graves were removed, and their remains were carried down Ponce to the Decatur Cemetery, where they are today.

PONCE DE LEON SPRINGS IN THE NINETEENTH CENTURY

In 1868, during the construction of the Air-Line Railroad, also known as the Beltline, the Ponce de Leon Springs were officially discovered. The railroad line was built by a crew of men who lived in traveling camps, and upon reaching the area that is now near Ponce de Leon Avenue, they found the railroad construction required them to bury their current source of water: Yancey Spring, which was located on the Todd property. Yancey Spring had been used by the few early settlers of the region for years. The railroad crew sought out a new source of water and found two very cold springs, six inches apart, which flowed from the base of a steep hill. The quiet nook where the springs were located was surrounded by ancient beech trees and also was located on the Todd land. Although the two springs were close together, they tasted different, each containing different minerals. One spring was a chalybeate spring, meaning it contained iron. A traveler in the 1870s described the spring waters as having a "sulfurous, nasty taste."

The railroad work crew had been suffering from various illnesses during the time it worked on the Beltline, and after a few weeks of drinking from the newly found springs, the men recovered. Whether the springs contained curative properties is a question that cannot be answered, but the men credited the medicinally flavored water with their cure, and the news traveled to the town of Atlanta.

Within two years, the two springs were jointly named Ponce de Leon Springs, and a new Victorian health resort was born. A medical doctor, Henry Lumpkin Wilson, is credited with naming the springs in honor of the Spanish explorer and his fabled Fountain of Youth. Dr. Wilson was the first official city physician of Atlanta, but after being injured in a fall from a buggy in 1885, he found employment in the real estate business and auctioned and sold property for the rest of his life. He and his wife lived on Peachtree Street and were active in the production of the 1895 Atlanta Cotton States and International Exposition.

In 1871, John M. Armistead, the son-in-law and heir of the long-dead Richard Todd, began to capitalize on the medicinal qualities of the Ponce de Leon Springs. He delivered the spring water for tips and sold rights to draw the water to different individuals and companies. In an 1872 lawsuit wherein Armistead claimed exclusive rights to the water, he stated, "Said waters are not sold, but complainant's profits arise from being liberally rewarded for the delivery." Armistead, a stonemason by trade, often began

drawing the spring water for delivery as early as 1:00 a.m., delivering to dozens of homes around Atlanta.

The popularity of the springs increased. Horses and carriages, mule-drawn wagons and lone horseback riders traveled to the springs. Some people started every day with a long drink from the springs. By 1872, Atlantans were traveling from downtown to Ponce de Leon Springs for fun, relaxation and to partake of the healthful waters of the springs. It was an all-day round trip to travel the two miles from the city to the springs, and the travelers usually went by way of Boulevard. A downtown hotel, the Kimball House, charged fifty cents per person for an excursion to the springs.

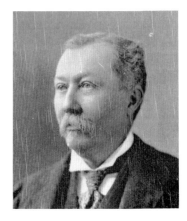

Henry Lumpkin Wilson named Ponce de Leon Springs.

Mass transit came to Ponce de Leon Springs via Richard Peters (1810–1889), quite possibly the industrialized New South's greatest supporter of all time. Peters had come to Atlanta from Philadelphia in the 1840s as an employee on the construction of the Georgia Railroad, the first railroad to connect Atlanta to the outside world. He was an urban promoter, meaning he had a hand in the city's earliest industry, politics, transportation, real estate, education and religion. Peters married Mary Thompson, daughter of J. Edgar Thompson, for whom he worked at the Georgia Railroad. Thompson is credited with creating the name "Atlanta" for the town of Marthasville. By "boostering" or promoting a city's growth, a man in those days could shape his own destiny. An Atlanta booster had a vested interest in the city's success and growth. Peters built Atlanta like no other antebellum man did through his remarkable foresight and intelligence. In 1856, one of his many business ventures was a steam-powered flour mill, and he bought Land Lots Forty-nine and Eighty (405 acres) for the pine trees that grew on the undeveloped land to fuel the mill's steam engine. It was the largest parcel of land owned by one person in Atlanta at that time. Those lots are around the western end of Ponce de Leon Avenue and run to the Georgia Institute of Technology's (hereafter referred to as Georgia Tech) campus today. The purchase of this land became a major source of Peters's great wealth in later years, although he had only paid five dollars an acre for it. Henry W. Grady (1850–1889), a journalist and orator who made the term "New South" nationally known, was one of Peters's pallbearers.

As Much Ground as There Ever Was

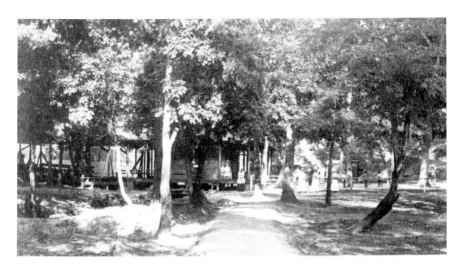

This stereoview photograph shows the Ponce de Leon Springs area in the 1870s.

In 1869, Peters, along with real estate auctioneer George Washington Adair Sr. (1823–1899) and other businessmen, created Atlanta's first mass transit system: mule-drawn trolleys. The cars of this new system, named the Atlanta Street Railway Company, carried sixteen to twenty passengers per car and sped through the streets of Atlanta at five miles per hour for a mere five cents a passenger. There were seven mules per car. The company had tried horses but found red-tailed Mexican mules were more durable. Each mule worked six days per week and was allowed one day to rest. In 1872, the trolley line traveled Peachtree Street from downtown to as far north as Pine Street.

By 1874, the Atlanta Street Railway Company had extended its trolley line down Peachtree Street and then turned east where Ponce is now located to end at Ponce de Leon Springs. At that time, Ponce de Leon Avenue did not officially exist. The streetcar company owned a private right of way, thirty feet wide, from Peachtree Street to the springs. The right of way was the predecessor to Ponce de Leon Avenue and was even more undulating and curvy than Ponce is today. Clear Creek crossed the right of way in the area between today's Myrtle Street and Argonne Avenue, around Penn Avenue. To cross over the deep ravine containing the creek, Peters's trolley company built a bridge for the streetcars to use for crossing the ravine. This trestle was 270 feet long and 40 feet wide, meaning that until the ravine was eventually filled in, technically, 270 feet of Ponce de Leon Avenue was suspended in the air as a bridge.

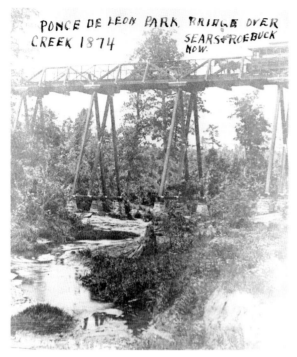

Some of the words written on this photograph are incorrect; the Sears Building was not constructed on this site, and Ponce de Leon Park is not depicted here. A bridge, built in 1874, crossed Clear Creek near where Ponce crosses Penn Avenue today. The photograph came from the Atlanta Museum, which was located at the Rufus M. Rose house on Peachtree Street. Most likely, its proprietor, James H. Elliott Sr., wrote on the photo.

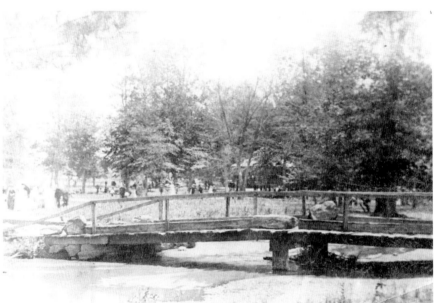

In the 1870s and 1880s, Ponce de Leon Springs was more of a picnic area than an amusement park.

As Much Ground as There Ever Was

In the late nineteenth century, trolley companies all over America used parks at the ends of their lines to increase revenue. Not only did the parks entice passengers to go farther down the line than intended (usually with an additional fare), but the parks also provided some motivation for people to use the trolleys on the weekends for recreation instead of only using them for transportation to work. Peters's streetcar company charged an extra five cents for passengers to ride past North Avenue to the springs.

The Gate City Street Railroad offered some competition to the Atlanta Street Railway Company by building a streetcar line in 1879 with the specific intent to carry passengers to entertainment venues, including Ponce de Leon Springs. Its organizers were Laurent DeGive, Levi B. Nelson, Augustus M. Reinhardt and John Stephens. Gate City applied for a building permit to build a pavilion at Ponce de Leon Springs in 1883. The pavilion's estimated cost was $3,500, and it was designed by the firm of Humphries and Norrman; Gottfried L. Norrman was and still is one of Atlanta's most esteemed architects.

By the 1880s, George Adair had sold his share of the Atlanta Street Railway Company to Richard Peters, and Peters had hired his son, Edward C. Peters, to be a general superintendent and a director in charge of the details of management. Back in 1874, when the trolley line was extended to the springs, the streetcar company had made an agreement with the owner of the springs, John M. Armistead, which allowed the passengers to visit the springs. Seeking to capitalize on the springs (not unlike the trolley company), in 1886, Armistead began charging five cents per person to drink from the springs. And from there, the battle for control of the lucrative Ponce de Leon Springs began. The following year, the Atlanta Street Railway Company bought the springs and thirty acres surrounding them, gaining control of the end-of-the-line park, thus uniting ownership of one trolley line and the springs.

It was at this time in the late 1880s and 1890s that the new owner of the springs put effort into making the springs and the land surrounding it into a public park. When Armistead had owned the land, the springs were in a more naturalistic state; the buildings were rough cabins, and the amusements were simple. People went to the springs to drink the medicinal waters and to commune with nature. The Atlanta Street Railway Company began to manipulate the grounds when it bought them. It leased the springs and surrounding land to N.C. Bosche, an Atlanta businessman, for development. In 1890, the trolley company hired landscape designer Julius Hartman to transform the area into a true recreational park. Hartman had designed Little Switzerland park near the neighborhood of Grant Park in Atlanta and

Little Tyrol park on Ponce de Leon Avenue; at the time, he was Atlanta's premier park designer. Under Hartman's direction in the summer of 1890, a four-acre lake was built directly across Ponce de Leon Avenue from the springs in the area that later became the Atlanta Crackers' baseball stadium and, eventually, a modern-day shopping center.

A smaller lake, Pairs Pond, was developed in the Ponce de Leon Springs park area in 1890 as well. Little is known about the lake's origin, other than that it was reported to have been located one hundred yards from the springs, was across the railroad and was named for William Pair. This would have put Pairs Pond somewhere in the vicinity of the parking lot shared by today's Ford Factory Lofts and Kroger supermarket. The 1880 federal census does indicate that a William Pair lived in the area and worked as a farmer. However, it is likely that the pond was connected to Thomas Coke Howard (1822–1893) in early years before Pair was associated with it. T.C. Howard is known to local historians for his involvement in General Sherman's east Atlanta headquarters during the Battle of Atlanta.

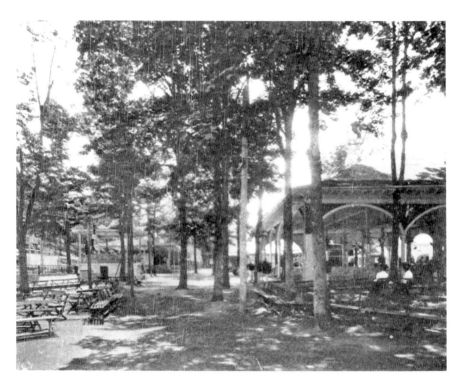

More substantial structures were built at Ponce de Leon Springs in the 1890s. The seated women appear to be wearing clothing from about 1900.

You are cordially invited to attend a

Private Dance,

to be given at Ponce de Leon Springs, Thursday night, Sept. 23, 1897.

——— **Committee :** ———

T. C. Goodson, G. S. Ehlers, John Hoylach

The area around the springs was not called Ponce de Leon Park until 1903.

Augustus Hurt (ancestor of Joel Hurt, who later developed the Inman Park and Druid Hills neighborhoods) owned a plantation in Land Lot Fifteen that contained a large white house. The house was used as Sherman's headquarters and is depicted in the Atlanta Cyclorama painting of the Battle of Atlanta. Throughout the correspondence, maps and memoirs of the Union troops, Hurt's white house is erroneously referred to as the "Howard House." Augustus Hurt had fled the armies and had left a slave to watch over the house during his absence. Thomas Howard—most likely with Hurt's permission—had taken up residence in the house, and this caused confusion for General Sherman and the Union soldiers, who assumed Howard owned the house. Howard was a lawyer, a member of the state legislature from Crawford County, postmaster of Atlanta during the Civil War and editor of the newspaper the *Intelligencer.*

Howard also owned an antebellum whiskey distillery, located between Augustus Hurt's house and Ponce de Leon Springs. Today's landmarks would put the distillery somewhere between the Sears Building on Ponce (site of the springs) and the Carter Center on Freedom Parkway (approximate site of the Hurt house). The distillery was one of the largest and most profitable distilleries in the South, using one hundred bushels of corn per day. Howard kept one thousand hogs on the land because the corn refuse could be eaten by them, providing another source of income while eliminating waste. In light of the Atlanta Street Railway Company's purchase of thirty acres surrounding Ponce de Leon Springs, the distillery land and lake could have been included. Furthermore, legendary history (although not always to be trusted) states that the pond was owned by T.C. Howard. In Elise Reid Boylston's *Atlanta, Its Lore, Legends, and Laughter,* she recounts a story of Pairs Pond:

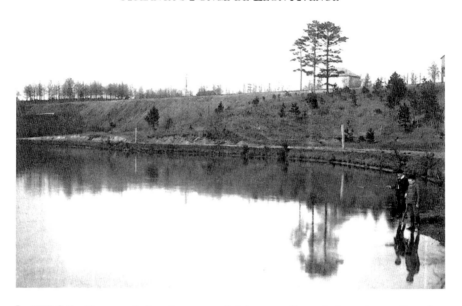

In 1890, Julius Hartman designed a man-made lake across Ponce de Leon Avenue from the springs. When the lake was drained in 1907, the Atlanta Crackers' stadium replaced the lake. Today, the Midtown Place Shopping Center is located in the valley where the lake was once located.

> *In it* [Ponce de Leon Park] *was a lake that was popular for boating and swimming, called Pair's Pond. It was originally Howard's Pond, and it was the most historical body of water in the city. It was built before the War by T.C. Howard, father of Hon. William Schley Howard, who owned the land. As was the custom in those days, men of means had their distilleries on their property, and the lake was artificially made to water the building. There were also fish raised in the lake—the first fish hatchery in the United States. Many of the boys who became leading citizens swam in it.*

FURTHER DEVELOPMENT OF THE AVENUE

The Ponce de Leon Avenue known to Atlantans today is actually a conglomeration of several smaller streets. On the western end of Ponce across Peachtree Street was land owned by Hannibal Ingalls Kimball, another early Atlanta businessman and booster. From Peachtree Street westward, the avenue was named Kimball Street in his honor. Today, Kimball Street would run from beside the Fox Theatre to where Ponce ends at the Varsity restaurant's parking lot. For a time in the 1880s and 1890s,

the part of Ponce from Peachtree Street to today's Piedmont Avenue was called Ponce de Leon Circle. Ponce ended at the springs for many years. In time, it inched eastward, and in 1908, when the Druid Hills neighborhood was beginning to be built, Ponce was extended to Decatur as Ponce de Leon Parkway. The street was also known in the early 1900s in a three-word form as Ponce DeLeon Avenue.

In the late 1870s, Richard Peters platted and named the streets in the land he owned around Ponce. In keeping with the tradition in his native Philadelphia, Pennsylvania, and to compliment Peachtree Street, at his wife's suggestion, Peters named the north–south streets on his land after trees or his home state: Myrtle, Juniper, Cypress, Cherry and Penn. He named the east–west streets numerically, with North Avenue counting as the first street and Ponce counting as the second street; the next east–west street is Third Street, and the numeration continues northward. This land of Richard Peters was the two land lots (405 acres) he had bought in the 1850s for the timber to harvest and fuel his flour mill. Peters did attempt to build a park-like neighborhood in his western lot in 1884—Peters Park—but it was a failure, and he ended up donating part of the land for Georgia Tech's campus in 1887. Peters's son Edward began selling his father's land on Ponce in the late 1880s and 1890s.

The age of the electric streetcar began in 1889, with developer Joel Hurt's Atlanta and Edgewood Street Railway Company leading in the transportation development race. This trolley originally ran from downtown eastward to the neighborhood of Inman Park and back. Later in 1889, a second electric trolley company was created, the Fulton County Street Railroad Company. It was soon called the "Nine-Mile Circle" because it did make a nine-mile circle from downtown through the northeastern portion of the city, crossing Ponce de Leon Avenue twice. The route was from Broad and Marietta Streets, to Peachtree Street, to John Wesley Dobbs Avenue, to Highland Avenue, to Virginia Avenue, to Monroe Drive, back to Highland Avenue and on into downtown again. The Nine-Mile Circle was primarily intended to service the neighborhoods of Copenhill (now part of the Inman Park Historic District) and Virginia-Highland. By 1912, the circle had been broken into two lines that traveled Monroe and Highland Avenues. In 1891, the Atlanta Street Railway Company merged with five other similar companies to form the Atlanta Consolidated Street Railway Company. Streetcar transportation on Ponce de Leon Avenue ended in the 1940s.

The Great Fire of 1917 changed the landscape of Atlanta and influenced the residents of Ponce de Leon Avenue. On May 21, 1917, the second-largest

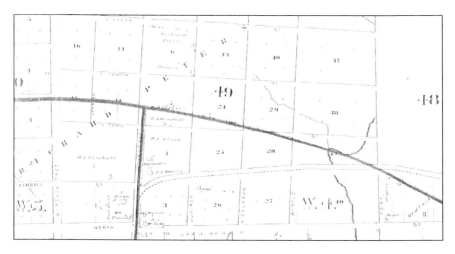

Mule-drawn trolley tracks on Ponce de Leon Avenue are indicated here by the dotted horizontal line. The bold lines show the Atlanta city limits and wards when this map was made in 1878. *C.M. Hopkins, City Atlas of Atlanta, Georgia.*

fire since the Civil War tore through the northeast section of Atlanta. The fire began right before 1:00 p.m. north of Decatur Street, between Fort and Hilliard Streets. The wind was blowing seventeen miles per hour. Earlier, firemen had been fighting three other blazes, thus rendering them short of men and water hoses. Soon, a fire—one thousand feet long and one block wide—was moving through the city at approximately the same pace as a man could walk. Some Atlantans believed they were experiencing a terrorist act by the Germans, as the United States had recently entered World War I. The fire continued to Ponce de Leon Avenue, where it burned from today's Charles Allen Drive to Glen Iris Drive, only crossing Ponce between Charles Allen and Monroe Drives. The Great Fire was arrested by selective dynamiting of houses around Ponce; the wind also died down, which decreased the blowing of burning embers, thereby slowing the travel of the fire. The fire had burned for ten hours in a seventy-three-block, three-hundred-acre area. Over nineteen hundred structures were burned, including at least five churches. Ten thousand people were made homeless in the ten hours it took for the fire to be stopped. As a consequence of the fire, Atlanta outlawed the use of wooden roof shingles and horse-drawn fire wagons.

William Berry Hartsfield (1890–1971) lived in the path of the Great Fire with his wife, Pearl, and young son, Willie. He was mayor of Atlanta for six terms—longer than any other mayor—and gave the city more than thirty years of public service. The Atlanta airport is named for him because of

his efforts in making Atlanta an aviation transportation hub. Willie B., the beloved silverback gorilla that lived at Zoo Atlanta for thirty-nine years, was named for him also. In a letter to some friends the day after the fire, Hartsfield describes its effect on his family and neighbors as only a person who has lived through such an experience can do:

> *You see, people were not experienced in conflagrations and put a great deal of their things in the street, but the fire swept the whole earth bare, streets and all, and everything no matter where it was—in vacant lots, in the streets, in gullies or elsewhere, was burned. You know the mass of beautiful shade trees along Boulevard and Jackson? Every one of them was burned down to a stump. Not a thing was left in the path, the ground was left hard and black, and that part of Boulevard that was paved with wood block was ruined.*
>
> *Practically all my stuff was burned that I had taken out in the back, excepting a few things I threw down the high bank and dragged two blocks down into the Ponce De Leon Woods, including our trunk, sewing machine, phonograph, and some blankets. Of course all our heavy furniture in the house went up. The people on Boulevard and Jackson saved nothing because they had nowhere to drag it, and everything in the streets and vacant lots burned, absolutely EVERYTHING except bricks and stones. What little we and the other people on the little side streets going down towards the woods saved was due to the fact that we dragged it down to the Ponce De Leon Woods. There were hundreds of people down there with what little they saved, including the usual amusing instances of where people would hang on to little cheap pieces of statuary, pitchers and bowls and let more important things burn...*
>
> *I was almost done in from taking stuff out and from dragging a heavy trunk and bed, clothes, sewing machine, etc. all the way over that bank and way down to the woods, and it was some time before I could find Pearl and the Baby down there among all those desolate, hand-wringing, despairing people.*
>
> *Poor Mrs. Agricola. I pulled her trunk out into the street for her. I know it must have been burned. Later on we saw her down in the woods walking around bare-headed with nothing but her canary bird in its cage...*
>
> *The fire swept everything before it from the old show grounds up Jackson, then up Boulevard and down both streets, taking in all side streets from Boulevard to the woods and on the Jackson side extending down Forrest to Bedford Place and down Pine for several blocks, but not to Mrs. Williams house. It stopped on Pine where those billboards are. It then went on over Boulevard Terrace, Boulevard Place, down Jackson and Boulevard taking*

everything down to Ponce De Leon and down Ponce De Leon to the Ball Park;
it jumped over Ponce De Leon and burned out one block further down, but
wholesale dynamiting done without stint and in desperation finally checked
it. The folks down in the woods were surrounded in a sort of semi-circle of
fire, and the roar of it sounded just like the roar of a heavy surf pounding,
although it was punctuated by frequent dynamite explosions, and we would
see the pieces of some fine house go up into the air and fall again...

Early this morning I borrowed my cousin's truck and drove over, but
the military, including regulars at the fore, were guarding the entire district,
and after much red tape I got permission to drive into the burned area and
had to take a sentry along with me to watch me get my stuff I had left in
the woods...I also drove up to the bared, charred hill where our pretty little
cottage once was and got what was left of Billie's little brand new bed.
As far as the eye could see was nothing but a sea of gaunt chimneys and
smoking piles of brick. It looked like a desert with exception of the chimneys
and here and there a charred stump of a tree or a telephone pole together
with tangled wires and once in a while a dead cat or dog and occasionally
a hot dry wind would sweep along filling one with brick dust. In front of
practically every house on Boulevard was the charred remains of a piano
that had been dragged into the street.

Ponce de Leon Avenue is wider than most Atlanta streets, and it became
an extra-wide street by accident. Until 1907, the city did not own the middle
of Ponce de Leon Avenue from Peachtree Street to the springs. The thirty-
foot right of way given to the Atlanta Street Railway Company in 1874 for
traveling to the springs still existed and was owned by its successor, the Georgia
Railway and Electric Company. On either side of the thirty-foot strip, the
city had built thirty-foot roads, resulting in a two-lane road with a strip in
the middle. Together, the roads and the strip equaled ninety feet. The strip
was visible in the middle of Ponce for many years. The Georgia Railway and
Electric Company, predecessor to the Georgia Power Company, donated the
strip to the city with the stipulation that no other streetcar company could
use the strip and with the agreement that it was not responsible for paving,
grading or any other upkeep of the strip. In 1956, some of the street was
widened more. The great girth of Ponce has contributed to the highway-like
effect of the avenue and likely has influenced its progression from residential
avenue to commercial corridor.

The street construction materials affected the lives of Ponce de Leon
Avenue residents. Initially, the avenue was a dirt road that ran beside the

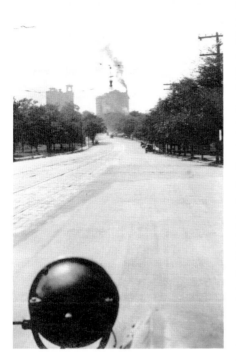

In 1924, when this photograph was taken, the streetcar right of way was still clearly visible in the center of Ponce de Leon Avenue. The Ponce de Leon Apartments and the Georgian Terrace Hotel are in the background, with the hotel emitting quite a bit of smoke from its boiler.

trolley line; then it became two dirt roads on either side of the trolley line. In the late nineteenth and early twentieth centuries, Atlanta paved its major roads, usually with wooden blocks, granite blocks quarried from Georgia's Stone Mountain (called Belgian blocks after the Belgians who were early paving employees) or macadam (a crushed rock mix of about eight inches thick). A tar coating could be added to macadam paving. In the early 1900s, Bitulithic paving was introduced, which was a mix of aggregate and cement; it was somewhat fluid and allowed earlier paving to be overlaid. A May 17, 1909 advertisement in the *Atlanta Georgian and News* reports that parts of Ponce de Leon Avenue had a problem with dust:

The Atlanta GasLight Company announces the establishment of a Road Tar Department for the purpose of furnishing Road Tar for the treatment of streets and roads afflicted with the Dust Nuisance. This Tar is also a destroyer of any germ infesting the public highways.

Ponce de Leon Avenue, from Piedmont to the Boulevard, is a good example of the efficiency of Road Tar in abolishing the Dust Nuisance. This road, 90-feet wide, was treated at the expense of property-owners for 11 cents per front foot.

Although the "Dust Nuisance" and tarring indicate a macadam road, at least part of Ponce was constructed with Belgian blocks. In 1910, the Fulton County commissioners voted to pave Ponce from Peachtree Street to the railroad at the Ponce de Leon Springs with Bitulithic paving. One hundred residents of Ponce de Leon Avenue had presented the county

commissioners with a petition requesting that the old Belgian blocks be covered with smooth paving.

Atlanta, like many other cities at the turn of the nineteenth century, grew in accordance with its transportation. In early days, when horses and trains were the only means of transportation, professionals and merchants worked and lived in towns and cities, and farmers lived in rural areas. People did not travel great distances to and from their employment on a daily basis. But when streetcars—and particularly electric streetcars—came into being, the concept of escaping work in the city to a more bucolic residential setting in the evenings became possible. Trolley neighborhoods sprang up, often, not coincidentally, on land owned by the trolley company owners. If an ambitious man could invest in a streetcar company and influence the route of the streetcar to pass by land that the same man owned, that man could get rich by developing a residential neighborhood on his land. A park-like setting and transportation to town were two qualities that sold real estate before the invention of the automobile. Joel Hurt (1850–1926) was Atlanta's premier utilizer of the trolley neighborhood concept with Inman Park and, eventually, Druid Hills on Ponce de Leon Avenue.

Similarly, Ponce de Leon Avenue's popularity as a residential street rose and fell, largely based on transportation. In the early twentieth century, Ponce was a picturesque street with excellent transportation to downtown and to Decatur by streetcar. Mansions lined the avenue. But when the automobile came into use, Ponce residents (and other city dwellers) moved from their urban setting to a suburban setting north of the city, making way for urban commercial development. Apartment buildings began to line Ponce around the time of World War I, and this also influenced the environment of Ponce. When the large homeowners of Ponce moved to the suburbs, the land they sold was perfect for apartment homes, often built by Atlanta's most esteemed architects. In 1910, the Atlanta City Directory listed one apartment building on Ponce; in 1925, there were thirty-six apartment buildings listed on Ponce. The single-family homes that were destroyed by the Great Fire of 1917 were mostly replaced with apartment homes. Still, Ponce de Leon Avenue remained an attractive street for apartment dwellers, homeowners and small businesses for decades. Often, the apartments were occupied by young, educated, newly married couples who had grown up during the time when Ponce was home to Atlanta's elite.

Automobile travel increased on Ponce throughout the twentieth century. Six highways use Ponce de Leon Avenue for part of their routes: U.S. Route 23, U.S. Route 29, U.S. Route 78, U.S. Route 278, Georgia Route 8 and

Georgia Route 10. Because of the street's use in interstate travel, as well as its convenient urban location, gas stations increased on Ponce de Leon Avenue in the 1920s and 1930s.

After World War I, Atlanta experienced a population boom. This boom in people, along with the invention of the automobile and the ensuing population flight to the suburbs, combined with the construction and location of the street itself, affected a change in the once ritzy avenue. Ponce de Leon Avenue gradually became a commercial zone instead of a residential street. Crime, drug dealing and prostitution became synonymous with the word "Ponce" in the late twentieth century. The elegant apartment buildings became run-down, many filled with derelicts. Social service organizations began planting the drug addicted, the homeless and the mentally impaired in the hotels and apartments on Ponce. In 1990, about twenty-three such organizations were operating within two miles of Ponce de Leon Avenue. Ponce became a dumping ground for problem citizens because it was not a residential street, not a real home to anyone.

While not publicly declared, it is an unspoken understanding in Atlanta among its citizens that Ponce became a dividing line between the white and African American communities around the 1950s, and this can be seen in the renaming of streets along the avenue. Some of the major streets on the south side of the avenue have different names than they do on the north side: Moreland Avenue and Briarcliff Road; Boulevard and Monroe Drive; and Parkway and Charles Allen Drives.

A revitalization effort started in the 1980s and accomplished some awareness of the decline of Ponce among groups such as the Ponce de Leon Task Force and the Ponce de Leon Improvement Association. The nearby residential neighborhoods of Poncey-Highland, Inman Park, Candler Park, Old Fourth Ward, Midtown, Virginia-Highland, Morningside, Lenox Park and Druid Hills increased their awareness of Ponce and actually started using the street for shopping. These efforts have continued, and Ponce is experiencing in the twenty-first century an even greater renewal than it did in the 1980s, although it is still a mecca for the state's most disturbed citizens.

But peeping through the fast-food restaurant signs, the graffiti and the empty buildings are the grand bones of Ponce de Leon Avenue. The roadway is still there, undulating in hills and valleys. The springs still flow under the ground, waiting to be tapped again. Many of Ponce's historic man-made structures are extant. The street is still convenient to downtown Atlanta. And as Sarah Medlock aptly stated over 140 years ago about the area around Ponce, there is as much ground as there ever was.

THE BEST STREET AND EVERYBODY KNOWS IT

A SELECTION OF HOUSES

Palatial mansions and, later, upper-middle-class homes, hotels and apartments began to pop up on Ponce in the years following the Ponce de Leon Springs' initial discovery and development; the trolley lines that led to the springs were convenient for homeowners' use too. The rich and powerful considered the street to be stylish yet rural. Politicians, real estate developers and business owners found the avenue to be a viable alternative to living downtown or along noisy Peachtree Street.

Atlanta's most beloved (and, paradoxically, also the most distrusted) carpetbagger—Hannibal Ingalls Kimball (1832–1895)—built a house around 1870 on the western end of what is today Ponce de Leon Avenue. During Reconstruction after the Civil War, the Northerners who flocked to the devastated South to make their fortunes in business and politics were called the pejorative term "carpetbaggers" by Southerners for the stereotypical suitcases they carried, which were made from used carpets. Kimball's house was located on the site of the Fox Theatre toward the rear of where the building is, on the northwestern corner of Ponce and Peachtree Street, facing Ponce, or what was then Kimball Street. Both the 1870 and the 1880 federal censuses list the Kimball family as living in that location. He was tall, charming, controversial and a Northerner, so Atlantans were

WORLEY'S BARGAINS WORLEY'S BARGAINS WORLEY'S BARGAINS WORLEY'S BARGAINS WORLEY'S BARGAINS WORLEY'S BARGAINS WORLEY'S BARGAINS WORLEY'S BARGAINS WORLEY'S BARGAINS WORLEY'S BARGAINS WORLEY'S BARGAINS WORLEY'S BARGAINS WORLEY'S BARGAINS WORLEY'S

W. E. WORLEY,

REAL ESTATE,

325 EMPIRE

BLDG.

Yes, we have got just what you want. Read for yourself and see.

ATLANTA IS THE BEST CITY IN THE South and Ponce DeLeon avenue is the widest and best street in the city, and everybody knows it; 90 feet wide and cars every three minutes. Let us start with three fine lots on Ponce DeLeon avenue, this side of the springs; used now as a tennis court, and as level as a floor. We do not want but one-tenth cash and yearly payments for five years. I have rock bottom prices on these lots.

BARGAINS WORLEY'S BARGAINS WORLEY'S BARGAINS WORLEY'S BARGAINS WORLEY'S BARGAINS WORLEY'S BARGAINS WORLEY'S BARGAINS WORLEY'S BARGAINS WORLEY'S BARGAINS WORLEY'S BARGAINS WORLEY'S BARGAINS WORLEY'S BARGAINS WORLEY'S BARGAINS WORLEY'S

"Atlanta is the best city in the South and Ponce DeLeon avenue is the widest and best street in the city, and everybody knows it." *Atlanta Georgian and News,* June 1, 1907.

not sure what to make of the transplanted Maine native when he arrived in Atlanta after the war. Upon his arrival to the state, Kimball associated himself with Georgia state governor Rufus Bullock, who was the state's first Republican governor and a notorious carpetbagger. Linton Stephens (half brother of Alexander Stephens, vice president of the Confederacy) referred to Kimball and Bullock as "unscrupulous adventurers."

Kimball adored his adopted city of Atlanta and all the possibilities it had as the South's Gate City. He became a liaison between Atlanta's boosters and Northern banks. Kimball made things happen in Atlanta, but he had one fault: his schemes were too ambitious for the times and often failed stupendously. Hannibal Kimball had his fingers in every enterprise of the

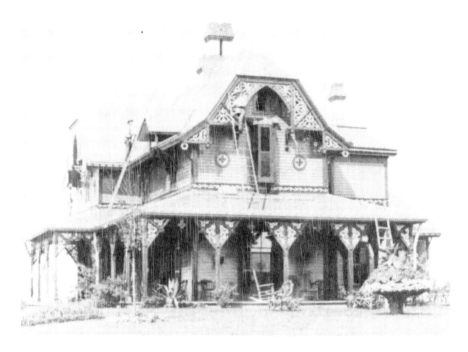

Hannibal Ingalls Kimball built this house for his family around 1870. It was located on the northwest corner of Peachtree Street and Ponce de Leon Avenue (where the Fox Theatre is located today), and the house faced Ponce.

city—railroads, education, expositions, charities, real estate development and hotels. He even was involved with having Georgia's capital city changed from Milledgeville to Atlanta. Kimball is most well known for the H.I. Kimball House, Atlanta's first grand-scale hotel in downtown. When the first Kimball House burned as the result of a careless, cigar-smoking lemon dealer, Kimball stopped at nothing to gather the funds that rebuilt the hotel within a year. Kimball moved his wife, Mary, and their children into a suite on the top floor of the rebuilt hotel when it was completed in 1885. The second Kimball House was demolished in 1959. Because of his failures, Kimball occasionally self-exiled himself to Europe or to his roots in New England, but he always came back to his adopted home city of Atlanta. On his last such exile, he died of stomach cancer at his brother's home in Massachusetts. He had been making plans to move back to Atlanta. Two people from Atlanta attended his funeral in Massachusetts: former governor Rufus Bullock and Samuel M. Inman, another one of Atlanta's celebrated boosters. Kimball is buried in Brooklyn, New York, where two of his children were buried.

Kimball's home lot was large and was soon subdivided so that it only faced Ponce de Leon, or Kimball Street, leaving two lots on the northwest corner of Peachtree Street and Ponce. The two lots on the corner that faced Peachtree were bought by Green Jonas Foreacre (1828–1886), a railroad executive, who, in turn, sold them to Willis E. Ragan, a wholesale dry goods company owner. The lot on the corner was used as a beautiful flower garden for many years, with the Foreacre/Ragan home situated next to it. Confederate captain Foreacre was the provost marshal of the Military Post of Atlanta in 1862, and it was he who was in charge of the Atlanta execution of the seven Union thieves during the failed Andrews Raid—the only locomotive chase in the Civil War.

Samuel Martin Inman (1843–1915) and his second wife, Mildred, built a three-story granite mansion on the southwest corner of Ponce de Leon Avenue and Peachtree Street. Unlike Hannibal Kimball's house, Inman's house faced Peachtree Street. The house was the scene of many social functions. It was built in 1888 and torn down in 1946. Because of his outstanding community service and interest in the city, Inman was known as Atlanta's "First Citizen" and affectionately called "Sam." Atlanta's first suburb, Inman Park, was named for him in the late 1800s. When the 1895 Cotton States and International Exposition in Atlanta's Piedmont Park almost had to shut its doors because of financial problems, Samuel Inman donated $50,000—a hefty sum today but extraordinary in the 1890s. Inman's generosity included contributions to churches, orphanages and colleges, particularly Agnes Scott Women's College in Decatur, Georgia.

Inman was a native of Tennessee and had come to Atlanta after the Civil War in 1867. Samuel and his brother Hugh were sons of plantation owner Shadrach Inman and had been educated well; Sam went to Princeton for two years before enlisting in the Confederate army. After the war, it was common for the same men who had been successful in large plantation farming to use those skills in business management to connect with others like themselves and, with those connections, form some of the strongest businesses in the reconstructed South. Thus, many former plantation owners of the antebellum South evolved into wealthy urban leaders after the war— but their success came from building cities instead of farming with slavery. The Inmans formed a cotton exchange company in Atlanta after the war and began to amass great wealth. At one time, S.M. Inman and Co. was the largest cotton brokerage house in the world. The exchange company acted as a middle man between the cotton farmers and the factories. In addition, the Inmans manufactured cotton textiles and cotton factory-related items and

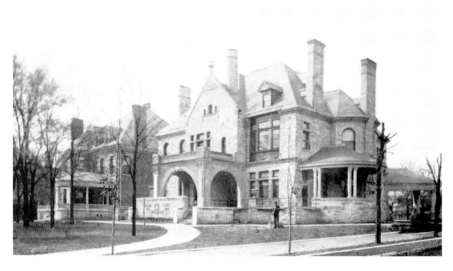

On the southwest corner of Peachtree Street and Ponce de Leon Avenue, facing Peachtree Street, was the granite mansion owned by Samuel Martin Inman. The brick house next door was owned by a candy manufacturer, Frank E. Block.

were involved in real estate development, wholesale dry goods, insurance, railroads and trolleys, banking and fertilizer.

The 1878 map shown in the previous chapter and the federal census records for that time indicate that Perino Brown (1824–1909) and his wife, Georgia, lived on the same lot where Samuel Inman later built. Brown was an antebellum and postbellum banker in Atlanta from Hall County, Georgia. He also served as treasurer of the city of Atlanta.

Both Hannibal Kimball and Samuel Inman eschewed public office, but Atlanta's thirty-seventh mayor, Mayor Livingston Mims (1833–1906), lived on the northeast corner of Ponce and Peachtree Street on the site of the Georgian Terrace Hotel. Mims served as mayor from 1901 to 1903. He and his wife, Sue, had a large, two-story frame house set far back off the road in a grove of trees surrounded by a wide lawn and flower beds. The house, named Heartsease, was painted yellow and had striped awnings over the windows. Heartsease was the Victorian name for the pansy flower. A brick walk extended from their front door to Peachtree Street. The Mimses started a Shakespearian society, which met at their home on the corner of Peachtree and Ponce. Mrs. Mims was a strong supporter of the Christian Science faith and was instrumental in the erection of the First Church of Christ, Scientist, at Peachtree and Fifteenth Streets. That church had met

in the Mimses' home before eventually outgrowing several locations and finding a permanent home.

Livingston Mims was an attorney and former plantation owner from Mississippi. He was on General Joseph E. Johnston's staff during the Civil War and went into the insurance business with Johnston after the war. Mims continued in the insurance business in Atlanta, but his mark on Atlanta was his great social prowess. His home was the site of lavish dinners, as the Mimses were known for their gourmet tastes. Mims was the first president of the Capital City Club and remained president for twenty years. He was a colorful character and was especially famous for his swearing and joking, doing so in presence of the ladies, including his neighbor Mrs. Sam Inman. Their daughter Emma Mims Thompson was president of the Board of Woman Managers at the 1895 Cotton States and International Exposition. She spoke in front of thousands at the opening day ceremony, along with Booker T. Washington—a first for a woman in the South. The Mimses are buried at Westview Cemetery in Atlanta. Upon her death, Mrs. Mims's will directed that all her jewelry be sold and used for the benefit of the Sidney Lanier Memorial in Piedmont Park.

The home of Henry Hunter and Estelle Cuyler Smith was located on the southeast corner of Peachtree Street and Ponce—the site where the

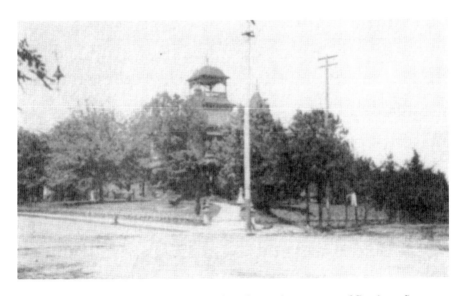

Mayor Livingston Mims's house was located on the northeast corner of Peachtree Street and Ponce de Leon Avenue, facing Peachtree Street. The house was demolished and replaced with the Georgian Terrace Hotel in 1911.

Ponce de Leon Apartments were built in 1913. The Smith house had the first upholstered porch furniture in Atlanta; Estelle bought the bright fabric abroad and had the porch furniture of her own design custom made. Their son (who lived with them before he married), Telamon Cruger Cuyler Smith (1873–1951), was known to be popular with the young ladies of Atlanta in the 1890s. After his father died, Telamon changed his name so that Cuyler was his last name. Although Henry was a cotton merchant and Telamon was a lawyer who also worked in the cotton market, both men were extremely interested in historical research. Telamon was a prolific history writer, focusing on the South and the Confederacy. In his later years, he wrote of his youth in Atlanta:

> *Livery stables had many buggies for rent and fellows took their best girls out driving on all fair summer days to Ponce de Leon Springs, Buckhead, Hapeville, and along the winding roads to the river…the carts which other young men and I used to drive about Atlanta in 1895 were so high that we installed blocks at the curb in front of our houses to use as steps… Pony carts, governess' carts, basket carts, and Shetland ponies once dotted Atlanta's tree-shaded streets.*

A little-known man of great importance in Atlanta's classical music history was Oscar Pappenheimer (1861–1917), who owned a house at the northeast corner of Ponce de Leon Avenue and Juniper Street. Although Pappenheimer was employed in the furniture-making industry, his real love was music. He was a major financial supporter of the New York Metropolitan Opera's visits to Atlanta and was in the forefront of every musical enterprise in the city. For over thirty years, musicians met at his home each Monday night for an informal concert. Pappenheimer's collection of rare musical scores was the finest in the South and one of the finest in the country. His white-columned wooden house was built around 1900 and burned in 1914. However, Pappenheimer immediately rebuilt almost the exact same house in the same spot, with the soul of the new home being the legendary music room. About one-third of the music manuscripts were saved from the fire. The music room—in both the old and new houses—contained a pipe organ of the size rarely seen in a private home and two Steinway grand pianos. Floor-to-ceiling mahogany paneling was installed on the walls of the music room, and built-in cases housed stringed instruments. The drawing room was decorated with the colors of gray and mulberry and exhibited oil paintings of music masters. The most

gifted professional musicians from Atlanta and all over the world played informal concerts at the Pappenheimers', and when he died, Atlanta's musical culture suffered. Besides working in the furniture business and providing a music salon for the community, Oscar Pappenheimer served on the City of Atlanta school board for ten years, most as vice-president. The Pappenheimer family lived in the house until the 1930s. After a brief stint as a Georgia Tech fraternity house, the columned mansion was converted to an ear, nose and throat hospital called the Ponce de Leon Infirmary. In 1977, it became the Midtown Hospital.

The Pappenheimer house's history ended on an unpleasant note when it became the Midtown Hospital, an abortion clinic that had to be forcibly shut down by the State of Georgia in 1998. Conditions inside Midtown Hospital reached horror movie levels, with tales of blood and urine on the floors, late-term fetuses expelled into toilets and severe overcrowding of patients. Records indicate that over seven thousand abortions were performed yearly under such unsanitary conditions. Despite efforts from Atlanta's Urban Design Commission and residents of the Midtown neighborhood to save

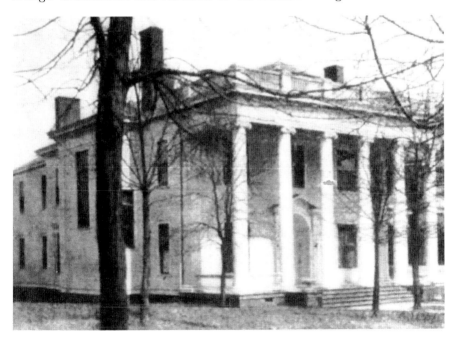

On the northeast corner of Ponce de Leon Avenue and Juniper Street was the home of music enthusiast Oscar Pappenheimer. This house was built around 1900 and burned in 1914. He replaced the first house immediately with an almost exact replica, which was demolished in 1999.

all or part of the house, it was demolished in 1999. Nothing remains of the Pappenheimers' house of music. By 2011, the Alexander on Ponce Apartments had been built on the site.

On the opposite side of the street, on the block between Juniper Street and Piedmont Avenue, were two houses of significance: the homes of the Atkinson family and the Knowles family. Both houses were built around 1890 and were elaborately designed wood-shingled mansions. Henry Murrell Atkinson (1862–1939) is most well known for his role as the founder of the Georgia Power Company. Atkinson's early training provided an excellent foundation for his extraordinary accomplishments in business. He came from a wealthy Massachusetts family and was educated at Harvard; however, he spent three years in the western part of the country as a cowboy, achieving a fearlessness that he later used in professional endeavors. In 1886, Atkinson came to Atlanta, and two years later, he married Richard Peters's daughter May. They had two sons, Jack and Henry.

As a driving force in Georgia's electric industry, Henry (or Harry, as he was known to his friends) dabbled in the electric streetcar industry because streetcar companies could own electric companies but not vice versa. For over a decade, 1890 to 1902, Henry Atkinson and Joel Hurt competed for control of electric, streetcar and steam-heat franchises, making a public spectacle of themselves in the courts and newspapers. The feud, known at the time as the "Second Battle of Atlanta," ended with Hurt's selling his interests to Atkinson, who then formed the Georgia Railway and Electric Company, predecessor to the Georgia Power Company.

Next to the Atkinsons' Victorian mansion was the home of Clarence Knowles (1853–1900), his wife, Fannie, and their two children. The Knowles house was designed by architect L.B. Wheeler, who was originally from New York and specialized in high Victorian styles. The house was located on the southwest corner of Ponce de Leon and Piedmont Avenues in the spot where St. Paul's Presbyterian Church is located today. Many Atlantans are familiar with St. Paul's as the church where the Abbey restaurant was located in the 1980s.

Clarence Knowles was a popular and kind man with personal magnetism. Originally from Florida, Knowles learned the insurance industry in New York and then cast his lot in Atlanta in the insurance business. He was the first president of the Piedmont Driving Club and a member of the state legislature, in which he served primarily to promote good fire insurance legislation. While he was in office, Knowles became an advocate for the poorer Georgia Tech students and worked to get a dormitory constructed with state

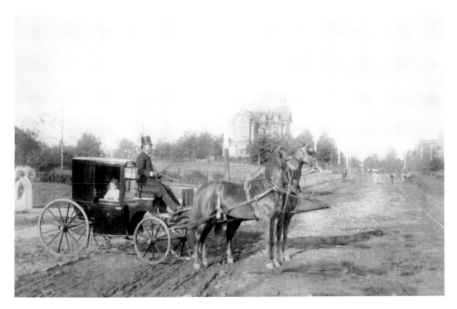

A carriage pauses on Ponce with Clarence Knowles's two children, Constance and Clarence Jr., inside. The names of the driver, the woman inside the carriage and the woman behind the carriage are unknown. Clarence Jr. was born in 1888, dating this photograph to about 1891. In the background is the mansion owned by Henry M. Atkinson. The horses were named Daisy and Dandy.

funds for their benefit; he brought his fellow legislature representatives to the campus to help convince them of the necessity of a dorm. The dormitory—Georgia Tech's first—was named for him. It opened in 1897. Knowles died in Florida but was buried at Oakland Cemetery in Atlanta.

Both James Maxwell Couper Sr. (1837–1918) and Edward Coyningham Peters (1855–1937) applied for building permits to construct houses on Ponce de Leon Avenue in 1883; the houses' building costs were estimated to be $12,000 each. Couper was a pioneer Atlantan and Civil War veteran. His house, a two-story frame dwelling located on the southwest corner of Ponce and Juniper Street, has been lost to obscurity. However, Peters's house still exists and has been reborn in recent years, providing Atlantans a glimpse into the lives of the nineteenth-century wealthy Atlantan on Ponce de Leon Avenue. Peters gave the house the name Ivy Hall, and after years of being called the Edward Peters House or the Mansion, it is again known as Ivy Hall—an art and design writing center for the Savannah College of Art and Design (SCAD). The house is perched on a hill on the south side of Ponce between Piedmont Avenue and Myrtle Street.

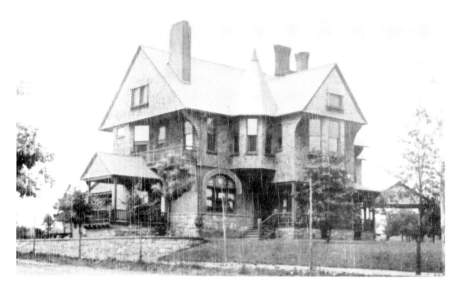

The house belonging to Clarence Knowles, shown here about 1890, was located on the southwest corner of Ponce de Leon Avenue and Piedmont Avenue, the site where St. Paul's Presbyterian Church is located today.

Edward was Richard Peters's son. Richard gave the land the house was built on to Edward as a wedding present; it had been part of the 405 acres he bought in 1856. Edward began working for the Atlanta Street Railway Company about the same time he built Ivy Hall. He began handling many of his father's business affairs and, eventually, taking them over at his father's death. Edward Peters was on the Atlanta City Council for decades, was a county commissioner and alderman and was involved with the city's purchase of Piedmont Park.

When it was first constructed, Ivy Hall contained 4,399 square feet. It was designed by the architectural firm of Humphries and Norrman, with Swedish-born architect Gottfried L. Norrman (1846–1909) being the primary designer. Norrman is best known for his post–Civil War, Queen Anne designs. In Atlanta, he designed the buildings for the 1881 International Cotton Exposition, some buildings at the 1887 Piedmont Exposition, houses in the neighborhood of Inman Park, the Hebrew Orphans Home and many other commercial, institutional and private structures in the city.

Today, Ivy Hall is one of the best examples of the Queen Anne shingle style of architecture still extant in Georgia. It survived the Great Fire of 1917 even though it was very near the conflagration. The house did not leave the Peters family until the death of Edward's granddaughter Lucille in

1970. In 1971, Ivy Hall was in danger of being demolished. The Victorian Society of America's efforts saved Ivy Hall, and shortly thereafter, it became home to a restaurant named the Mansion. The main part of the house was rarely used in the restaurant business, but it provided a backdrop to the fine cuisine. A generation of Atlantans experienced the Mansion as a place to have dinner before their high school proms and other celebratory affairs. In 2006, after another demolition scare, the owner of the Mansion donated the house to SCAD. After two years of restoration efforts and $2 million, Ivy Hall has regained its nineteenth-century glory. The original staircases carved with ivy leaves and the paneling, fireplaces and floors still exist despite some rocky times prior to restoration, including a small fire.

On the western corner of Ponce and Durant Place was the Colonial-style home of Edward Mortemer Durant (1868–1946) and his wife, Abbie. They lived in the house with their sons Armand and Ross. Edward was in the insurance business, and Abbie's entertainment efforts frequently made the society pages of the newspapers. The street adjacent to Edward Durant's house—Durant Place—was obviously named for Edward Durant and his family, and it was here that he lived when he made some Atlanta history. In 1909, Asa G. Candler Jr. (the Coca-Cola Company founder's son) and Edward Durant decided to create the Atlanta Speedway for automobile racing, a completely new sport at the time. The two formed a group, the Atlanta Automobile Association, and this association, of which they were both officers, bought the land and built the speedway on three hundred acres using one thousand laborers and one hundred mule teams. The two-mile

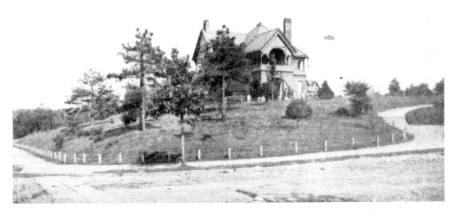

Ivy Hall, seen here in 1890, is located on the southeast corner of Ponce and Piedmont Avenues.

course was located at the site of today's Hartsfield-Jackson International Airport and was short-lived. The Durants moved to Buckhead and built a white columned mansion in 1916 on Peachtree Road. In 1921, the Durants sold the house to Hiram Wesley Evans—imperial wizard of the second Ku Klux Klan—who used the house as a headquarters for the Ku Klux Klan from 1922 to 1936. The mansion and surrounding four acres were sold in 1937 and became the campus of Christ the King Cathedral and School.

Another Atlanta mayor lived on Ponce de Leon Avenue—four-term mayor James L. Key (1867–1939). He was mayor from 1919 to 1923 and during some of the toughest Depression years of 1931 to 1937. Key made national headlines when he spoke out against Prohibition while on a trip to France in 1931. He was one of the first politicians in office in the country to take a liberal stand in favor of alcohol sales, and he was met back in Atlanta with a backlash of anger. Atlantans demanded a recall of the 1931 election in 1932, and Key won the revote. However, he did feel pressure from his church, Grace United Methodist on Ponce, and he resigned from being a longtime Sunday school teacher because he refused to agree to promise not to mention Prohibition. It was not that Key intended on mentioning Prohibition at church but that he was insulted that his church would believe him tasteless enough to mention it. Within a short time, Mayor Key was teaching a men's Bible class of one thousand people in a local theatre. Under his leadership, the WPA made improvements to Atlanta's sewer system. Key was a lawyer and lived on the south side of Ponce with his wife, Ella, and daughter Ruth. Their house was just east of Hunt Street.

On the north side of Ponce, east of Bonaventure Avenue, was once a house belonging to Walter McElreath (1867–1951) and his wife, Bessie. McElreath was a lawyer and a representative from Fulton County to the state general assembly, but he is best known as the primary founder of the Atlanta Historical Society, predecessor to the Atlanta History Center. He and fourteen others founded the society in 1926, and he bequeathed his residual estate worth about $5 million to it. These funds boosted the small society's success, allowing it to purchase the Swan House and surrounding property where the Atlanta History Center is located today. Walter McElreath was very involved in Grace United Methodist Church on Ponce and served for nineteen years as chairman of its board of stewards. McElreath bought his eight-room Ponce de Leon Avenue house when it was new in 1913 and lived there until 1928. The couple first lived on East Avenue in the Old Fourth Ward area near Ponce, but in 1912, they had

begun coveting the new houses being built on Ponce. Walter McElreath believed there was no more desirable place to live in Atlanta than on Ponce de Leon Avenue. He said, "Elegant houses were then building on Ponce de Leon Avenue, and it was regarded as one of the more prominent residential streets in the city, then just in the beginnings of its development."

When the McElreaths first moved to Ponce in 1913, there were fewer than a dozen houses between his house and Moreland Avenue, but the street became what he termed "decadent" in the 1920s. The couple moved to Buckhead when apartment houses were built on Ponce in the 1920s, putting out great clouds of smoke from their boilers and ruining the air.

Judge John Slaughter Candler (1861–1941) built the first house in the neighborhood of Druid Hills in 1909. He was a lawyer, serving as a Georgia Supreme Court justice from 1902 to 1906. Candler held numerous positions in the state government and militia. John Candler was also the brother of Coca-Cola Company founder Asa Griggs Candler. His French Colonial–style house cost $30,000 to build; at the neighborhood's inception, the Druid Hills building covenants required building costs of the houses in the neighborhood to be at least $7,500. It was designed by Gottfried L. Norrman, who also designed Ivy Hall. Although large, the house was a one-story bungalow and was located on the northeast corner

Ponce de Leon Avenue was a tree-lined residential street in the early 1900s.

of Ponce and Briarcliff Road. In the 1930 federal census, Candler and his wife, Florrie, were living in the house with a housekeeper, cook, maid, gardener and chauffeur. It was razed in 1952, and the site today is where Druid Hills United Methodist Church stands.

The Clyde Lanier King house is located on the northwest corner of Oakdale Road and Ponce de Leon Avenue and was built in 1910. King lived in the house with his wife, Clara, and their three children. Clyde (1884–1941) was the brother of George King, the Atlanta hardware store magnate. Like his brother, Clyde King also struck his fortune by selling supplies to farmers; however, he owned a plow company, today known as the King Plow Art Center on the west side of Atlanta near Georgia Tech. When he first purchased the company with a few partners in 1902, the company was named the Atlanta Agricultural Works. In 1906, the name was changed to the Atlanta Plow Company, and in 1928, King bought out his partners and renamed the company King Plow Company. Clyde King was active in the Capital City Club, the Rotary Club and Central Presbyterian Church and was a founder of the Druid Hills Golf Club. His grave monument at Oakland Cemetery is a replica of his house. The legend is that King so wanted to be buried on the grounds of his home on Ponce (which was not allowed under a city ordinance) that he built his tomb to look like his house. Today, the house is home to the Alpha Delta Pi sorority national headquarters and has been since 1955.

George Washington Adair Jr. (1873–1920) and his brother Forrest Adair (1865–1936) also built houses around 1910 in the Druid Hills section of Ponce de Leon Avenue. Since then, Forrest Adair's house at 1328 Ponce has been divided into condominiums, and George Adair's house at 1492 Ponce has been replaced with the town homes called Lion's Gate. In 1908, the two brothers, along with help from Asa Candler Sr. and Preston Arkwright (Georgia Power president), bought land from Joel Hurt and finished Hurt's and Frederick Law Olmsted's plan of developing the neighborhood of Druid Hills. The Adair brothers were the only real estate agents allowed to sell the Druid Hills property. Their father, George Washington Adair Sr., was involved in most of Atlanta's early real estate transactions, and he started the Atlanta Street Railway Company with Richard Peters in 1869. During the Civil War, George Adair Sr. was on the staff of General Nathan B. Forrest and cultivated a deep friendship with Forrest until his death, which probably accounts for his son's name.

THE DELUGE OF MULTIFAMILY DWELLINGS

In the early twentieth century, hotels and apartments came into being on Ponce de Leon Avenue, and the avenue's landscape from Peachtree Street to North Highland Avenue changed forever. Back in those days, the difference between a hotel and an apartment was sometimes almost nonexistent, and thus the term "apartment hotel" was included in the names of many of the early multifamily residences. Many single men and young couples rented out hotel suites as permanent living quarters, and this set-up evolved into apartment house living in the city. A hotel could provide a young adult with the advantages of living independently while providing services such as security, meals and laundry service.

Joseph Francis Gatins Sr. (1855–1936) built the Georgian Terrace hotel in 1911 on the corner lot where Livingston and Sue Mims's house had been located. Billed as a fancy Parisian hotel, it was a smashing success from its beginnings. Five thousand people came to the hotel's opening and were serenaded by a Spanish orchestra in native costume. Gatins, an Atlanta entrepreneur and New York Wall Street investor, was reputed to be worth $10 million in his day, some of which was made in unlawful "bucket shops" in New York. A bucket shop is a business where illegal betting on the stock market takes place. However, Gatins maintained a good reputation in Atlanta, despite the scandal. Joseph Gatins placed the hotel in trust for his three children and their descendants in 1912, and Joseph F. "Joe" Gatins Jr., Joseph F. "Francis" Gatins III and their families all lived in the hotel at different times in their lives. Joe and his wife, Eglé, moved into the hotel turret apartment in 1914. Eglé drove her Model T Ford on Ponce and took golf lessons at the Druid Hills Country Club. Francis's son—the fourth Joseph Gatins in the family line—lived in the Georgian Terrace as a boy in the winters and recently attended the one-hundred-year anniversary of the opening of the hotel.

The architect of the Georgian Terrace Hotel was William L. Stoddart (1868–1940), and the bulk of his work was in designing southern hotels. He was extremely prolific, building such hotels as the Lord Baltimore Hotel in Baltimore, Maryland; the Hotel Charlotte in Charlotte, North Carolina; the Francis Marion Hotel in Charleston, South Carolina; and the Reading Hotel in Reading, Pennsylvania. Two years after the Georgian Terrace Hotel was built, Stoddart designed the Winecoff Hotel in Atlanta (now the Ellis Hotel). It was severely damaged in a 1946 fire and holds the record for the most deaths in a hotel fire in the country.

During the Metropolitan Opera's yearly visits to Atlanta, beginning in 1910, the troupe, with the internationally known tenor Enrico Caruso, stayed at the hotel. Caruso was known to hold court on the outdoor terrace overlooking Ponce, holding teas, drawing amusing caricatures of friends and giving the corner of Peachtree Street and Ponce de Leon Avenue an ambience of the French Riviera. It was a magical time in pre–World War I upper-class Atlanta—there was money to be made, automobiles were new and men wore top hats as often as possible.

When the movie *Gone with the Wind* premiered in Atlanta in 1939, the cast of the movie, including Vivien Leigh and Clark Gable, stayed at the Georgian Terrace Hotel. The day before the premiere of the movie, a parade took place on Peachtree Street from downtown to the Georgian Terrace; about 300,000 people lined the street. A platform was constructed from the street into the hotel so that the parade members could walk with ease from their floats into the hotel.

Two United States presidents have stayed at the hotel: Warren Harding and Calvin Coolidge. When the Ponce de Leon Ballpark was in operation, the visiting teams usually stayed at the Georgian Terrace and were often seen walking down Ponce toward the ballpark. A nineteen-story wing was added when the Georgian Hotel was renovated in 1991, and the hotel was renovated again in 2009.

The Ponce de Leon Apartments (known as The Ponce Condominium since 1982) on the southeast corner of Ponce and Peachtree Street was built by the George A. Fuller Company and designed by the same architect as the Georgian Terrace, William L. Stoddart, in 1913. As Atlanta's first luxury apartment building, it was built to be an extravagant example of what apartment living could be and still stands today, along with the Georgian Terrace Hotel, seemingly as sentries, guarding the entrance from Peachtree Street to the once elegant Ponce de Leon Avenue. Both buildings' rounded sides seem to emphasize their roles as entrance keepers to Ponce. From this corner of Ponce and Peachtree Street, tenants of the Ponce watched the Great Fire of 1917 from the roof. When *Gone with the Wind* premiered in Atlanta and a parade culminated at the Georgian Terrace, the streets were filled with thousands of people, and victims of the crowd's crush were resuscitated inside the lobby of the Ponce de Leon Apartments.

The original layout of the Ponce de Leon Apartments allowed for each floor to have several large apartments of nine or ten rooms and four bachelor suites; the tenth and eleventh floors were composed entirely of bachelor suites. These bachelor units were small and usually did not have

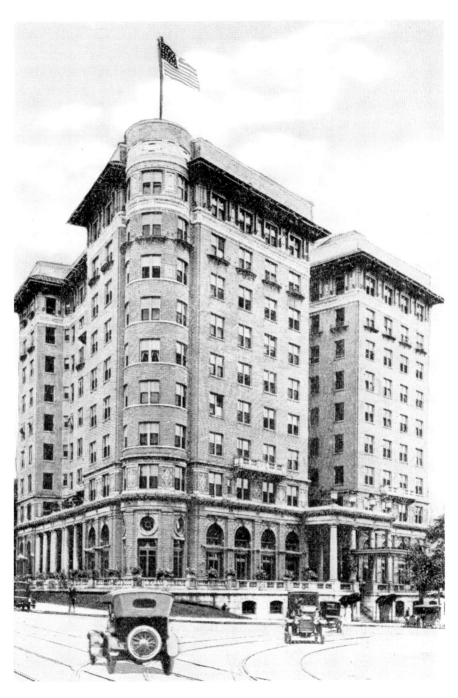

The Georgian Terrace Hotel is depicted here about 1915.

kitchens. The apartment building's dining room served meals for thirty-five dollars per month to young men who did not have wives to cook for them, because in those days, a young, upper-class man was ignorant about food preparation. Originally, the building had a pharmacy and a bookstore on the first floor. There was an ice plant in the basement, and the building staff delivered blocks of ice to the residents at 8:00 a.m. daily at no extra cost.

The Ponce de Leon Apartments contained Atlanta's first penthouse apartment. In 1932, Margaret "Peggy" Oliver, wife of J.M. Oliver, who was operating manager at Georgia Power, created the first penthouse; she had been influenced by the penthouses in New York. Peggy Oliver provided a stylish addition to the Ponce and to Atlanta by decorating her new penthouse in the Art Moderne style and wearing pajamas to greet guests when entertaining.

Inside the Ponce today, the building looks much like it did when it was built in 1913. Marble floors, rich wood carvings and a Tiffany stained-glass ceiling still embellish the lobby. Some of the owners have enlarged their condominiums by purchasing the original bachelors' apartments and merging their units. It is a cozy, classy, step-back-into-time inside the Ponce, and the excitement of a rooftop view of the neighboring Georgian Terrace and Ponce de Leon Avenue continues today, as it did in its early years.

The majority of hotels and apartment buildings that sprouted alongside Ponce throughout the twentieth century did not possess the grandeur of the Georgian Terrace Hotel and the Ponce de Leon Apartments; however, some of them could boast of architectural design by important Atlanta architects. One of these was the Rosslyn, located on the northwest corner of Ponce and Durant Place. It was built in 1913—the same year as the Ponce de Leon Apartments—and was designed by Leila Ross Wilburn (1885–1967). The apartment building was named for her. Wilburn is famous for being Atlanta's first successful female architect. She went to college at Agnes Scott for one year and then apprenticed under Benjamin R. Padgett Architectural

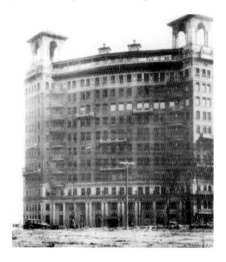

The Ponce de Leon Apartments, now called The Ponce Condominium, is shown here about 1913.

and Engineering firm for two years. In 1908, she opened her own office. Wilburn's designs were exclusively residential and were popular because she understood domestic planning of a dwelling in a way only a woman could. She knew where to put the closets and the windows and the staircases so that it made sense to the homemaker from a practical viewpoint. She designed at least eighty houses, twenty apartment houses and twenty-four duplexes in Atlanta. Wilburn created pattern books or catalogues for her home designs; these were used often by unknown builders, leaving many Wilburn-designed structures unknown today.

Dark red brick and concrete define the construction of the Rosslyn. Originally, there were four apartments on each of the three floors, consisting of five or six rooms each. The second and third floors each had an additional small apartment consisting of one room and bath. All of the modern conveniences of the day—such as hot water, dust chutes and a built-in vacuum cleaner—were available for residents of the Rosslyn.

Today, the Rosslyn and the apartment complex next door make up the Atlanta Transitional Center, a halfway house for recently released prisoners. The next-door apartments were named the Three Thirty-Two Apartments and were designed by well-known Atlanta architect G. Lloyd Preacher in 1921. A mid-twentieth-century hotel, the Cherokee Motor Inn, once occupied the space just to the west of the Atlanta Transitional Center. That space is vacant now and serves as part of the center's parking lot. The

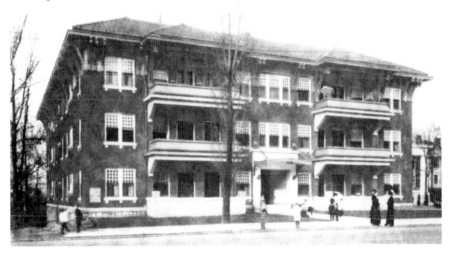

The Rosslyn Apartment building, on the northwest corner of Ponce and Durant Place, was designed by architect Leila Ross Wilburn and built in 1913.

The Shady Rest was a group of buildings used as a hotel in the late 1920s. It was located where the Yaarab Shrine Center is today. The building in the top left corner is the only one still standing.

1911 Sanborn map of this area indicates the lot at that time was large and consisted of the Rosslyn lot, the Three Thirty-Two Apartments lot and the Cherokee Motor Inn lot, with a house situated in the far northeast corner of the lot.

The Shady Rest Tourist Home was an example of the gracious homes of Ponce turning to more commercial endeavors in the late 1920s. It was made up of several houses, all of which have been demolished, except for the westernmost building. The Shady Rest served as lodging quarters for travelers on the increasingly busy Ponce de Leon Avenue. Horace and Zula Murdock owned this travelers' lodge where they also lived, and Horace was a salesman by profession. Today, the Yaarab Shrine Center is located on the site of the Shady Rest.

Located on the northeast corner of Ponce de Leon Court and Ponce de Leon Avenue was the Bais de Leon Apartments. The apartment building was designed by architect A.F.N. Everett around 1922. Everett is particularly known for his 1934 design of the Evans-Cucich house on Peachtree Battle Avenue—Atlanta's only Art Deco private home. Clifford Jerome Baisden, a wholesale produce company proprietor, was the owner of the building. Later in the twentieth century, it was called the Chestatee Apartments, which were

The Bais de Leon Apartments are shown here about 1922. The name changed later to the Chestatee Apartments.

demolished, and today a small shopping center has been built on the site that contains an automobile oil changing business and other small businesses. All that is left of the Bais de Leon is the brick retaining wall near the street.

In 1924, the Bonaventure Arms Apartment building was built on the south side of Ponce, on the southwest corner of Ponce and Bonaventure Avenue. To most Atlantans, the name it was changed to around 1940 is more familiar: the Clermont Motor Lodge. At that time, the building became more of a hotel than an apartment building and catered to traveling motorists. According to local legend, notorious gangster Al Capone once rented out the entire top floor of the hotel. The architect was William Harold Butterfield, who worked at one time as a draftsman for famed Atlanta architects Hentz, Reid and Adler. Butterfield was from New York and moved to Belgium in 1924. Originally, the building contained 74 apartments. The hotel now contains approximately eighty-eight thousand square feet with 124 rooms, and there is still a fallout shelter from the World War II era in the basement. Over time, the Clermont Hotel deteriorated, and it was shut down by the Department of Health in 2009 for a host of health code violations. It is currently empty—except for the Clermont Lounge in the basement—and is on the market for sale.

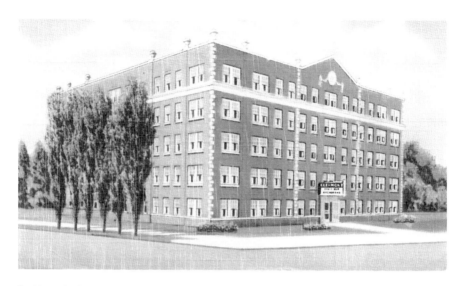

In 1940, the Bonaventure Apartments, which were built in 1924, were converted into the Clermont Hotel.

There is a vast open space today on the south side of Ponce between Barnett Street and Bonaventure Avenue that once was home to dozens of single-family houses and several apartment hotel buildings. These structures, as well as many more throughout the area, were all demolished to make way for a proposed highway that would have cut through Atlanta's most historic neighborhoods on the northeast side of Atlanta, virtually destroying what was left of the many historic neighborhoods of the city by making them unlivable. Today, the demolition area in the city is known as Freedom Park, a long, linear bike path and green space that makes use of the area.

While the highway proposal started brewing in the 1960s, it really gained traction in the 1980s. This highway—the Stone Mountain Tollway, or I-485—was planned to run from downtown Atlanta to the Stone Mountain area in DeKalb County, bisecting the city of Atlanta. However, the historic neighborhoods fought back. They took on the instigator of the highway, the Georgia Department of Transportation, in a mass grass-roots effort. And they won. In the early 1980s, the local citizens created two groups: CAUTION (Citizens Against Unnecessary Thoroughfares in Older Neighborhoods), which was the legal arm of the citizens' fight, and the Roadbusters, an activist group known for protests and for putting themselves in harm's way to stop the bulldozers. The Roadbusters are famous among Atlantans for chaining themselves to trees in the paths of bulldozers. Both

groups and efforts from all the historic neighborhoods helped put an end to the planned highway, and an agreement was made in 1991. The groups that fought the state in what has become known as the "Road Fight" eventually evolved into the Freedom Park Conservancy, which serves as an advocacy group for the park.

On the northwest corner of North Highland and Ponce de Leon Avenues is a spectacular hotel currently on the eve of a total remodel: the Briarcliff Hotel. It was originally known as the Seven-Fifty. Then the street numbering system changed in Atlanta, and it became known as the Ten-Fifty. In 1982, the building was renamed Briarcliff Summit and became a government-assisted residence for the disabled or elderly. Not unlike the Clermont Hotel, it is rumored that Al Capone kept a suite in the Briarcliff. Like many other hotels of the time period, it catered to young men and newlyweds as an alternative to a single-family home. The nine-story building was built in 1924–25 as a luxury apartment and residential hotel. It is H-shaped and

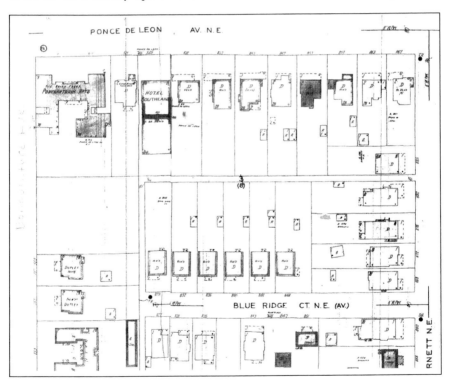

All of the dwellings shown here were demolished before the end of the 1980s in preparation for the building of a proposed highway, which was never built. The area is now part of Freedom Park.

constructed with brick, stucco and limestone. The most striking feature of the building's construction is the colorful terra cotta decoration around the top of the building.

The builder was Asa G. Candler Jr., son of the senior Asa Candler of Coca-Cola fame and nicknamed "Buddie." The younger Asa Candler kept a nine-room apartment on the top floor for his family, as well as the offices for his real estate company, and he lived there during the last years of his life. He died in the Briarcliff Hotel in 1953 after suffering from a three-month illness. Briarcliff Road, which crosses at Ponce to become Moreland Avenue, received its name from Candler's "country" estate, named Briarcliff. This estate on Briarcliff Road is now Emory University's Briarcliff Campus. Asa Candler Jr. was troubled—suffering from alcoholism and depression—and his Briarcliff estate was an odd assortment of swimming pools, a zoo and a farm. The mansion contained a room solely for housing his magic trick paraphernalia. Although Asa Candler Jr. worked successfully at Coca-Cola and later in real estate, his life was marred by his unusual habits and mental condition.

Renowned architect Geoffrey Lloyd Preacher (1882–1972), who also designed Atlanta's gothic city hall building in 1929, was the designer of the Briarcliff Hotel. As one of the most significant commercial and institutional architects in the Southeast, Preacher is particularly known for his hotel, office, school and apartment building designs in Atlanta. He was from South Carolina, educated at Clemson University and began his career in Augusta, Georgia. Preacher designed 417 structures in seven states. Forty-five schools in Atlanta were designed by G. Lloyd Preacher, including Bass High School (1923), Mary Lin Elementary School (1928–30) and a gymnasium addition to Inman Middle School (1929). Preacher and his wife, Fannie, lived at 1627 South Ponce de Leon Avenue in Druid Hills with their three children. Their house was built around 1929 and still stands today.

Other hotels and apartment buildings sprang up by the dozens on Ponce de Leon Avenue between 1910 and 1930. Some of these are as follows: the Kenilworth/Ivanhoe Apartments (1916), the Ponceanna (1917), the Wyoming Apartments (1919–20), the Grove Park (circa 1920), the One-Ninety Apartments (G. Lloyd Preacher, 1921), the Grandeleon (1922), the Druid Court Apartments (A.F.N. Everett, 1922), the Massellton (Emil C. Seiz, 1924) and the St. Augustine Apartments (1924). The Ponce de Leon Hotel, on the south side of Ponce between Glen Iris Drive and Boulevard, was built around that same time period and is in the heart of the current drug and prostitution culture on the avenue, near the intersection of Ponce

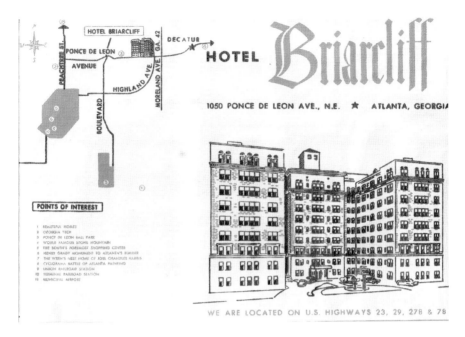

Shown here is a souvenir paper placemat from the 1950s. *Courtesy of Pat Westrick.*

and Boulevard. On the north side of Ponce near Barnett Street is the Lake Chiropractic of Georgia Building, built in 1964. Dr. Grady Lake, a chiropractor, built the structure to house his practice, and the upper floors were rented out as apartment units. It is made of steel and concrete and has a mid-century motif. Dr. Lake died in the late 1990s, and the building is currently empty and on the market. On the south side of Ponce in the 800 and 900 blocks are a number of single-family houses that have been turned into office spaces. The Providence on Ponce, built in the 1960s at 985 Ponce de Leon Avenue, was originally a church and is known for being, allegedly, the first church turned into condominiums in Atlanta.

Chapter 3
OUR NOBLEST EFFORTS FOR HUMANITY

With home-building comes a community, and with a community come schools and churches. The early residents of Ponce de Leon Avenue sought edifices of higher learning—intellectual and religious—and they built them nearby for convenience. As Ponce declined in the mid-nineteenth century, some of the institutions of higher learning followed their members to the northern suburbs of the city, and some of the churches and schools stayed on Ponce and adapted. Adaption is the key to the survival of these institutions on Ponce. Churches that once accommodated Atlanta's wealthy leaders have learned to attract middle-class families; these new church members work in a hands-on capacity with their less fortunate neighbors on Ponce. The schools and churches on Ponce range from public education to private, from the Hare Krishna religion to Methodist. Ponce de Leon Avenue has reinvented itself in the last few decades, and its noble learning institutions have reinvented themselves as well; they are thriving and reaping their human harvest.

St. Paul's Presbyterian Church occupies the building originally built by the Ponce de Leon Methodist Episcopal Church, formerly Egleston Memorial (established 1867), which had been located downtown on Washington Street. The church was filled to capacity at its first service on Ponce on November 12, 1916. It is situated on Clarence Knowles's old lot on the southwest corner of Piedmont Avenue and Ponce. In 1915, Egleston Memorial bought the lot, along with the Knowles mansion, for $50,000. The house, which was twenty-

five years old at that time, was moved 150 feet back from Ponce and turned to face Piedmont Avenue. The congregation turned the upstairs into an apartment for the minister, and the downstairs parlors became chapels for the church members. Knowles's grand Victorian house was demolished in 1950.

Charles H. Hopson (1865–1941) designed the St. Paul's building. He was originally from England and was a church architect for over fifty years, designing two other churches in Atlanta: Rock Springs Presbyterian in 1923 and Peachtree Christian in 1928. The Faith Memorial Church purchased and renovated the building and built additional classroom facilities in the 1950s. In 1977, the church building was turned into the business for which the building is most famous: the Abbey Restaurant. Novelist and critic Elliott Mackle described the Abbey in an April 14, 1995 article in the *Atlanta Journal-Constitution* as "skillfully positioned between sacrilege and titillation." The restaurateur, William Swearingen, also owned the Mansion Restaurant next door at Edward Peters's old house. St. Paul's Presbyterian purchased the church building in 2006.

The first church built on Ponce was the Ponce de Leon Baptist Church, located on the northeast corner of Ponce and Piedmont Avenue. Its first

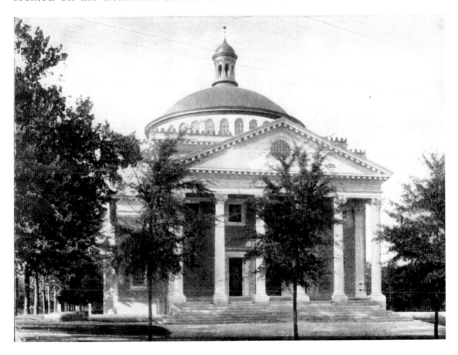

Ponce de Leon Baptist Church was the first church built on Ponce de Leon Avenue. This postcard depicts the church about the time it was built, 1906.

service was on September 9, 1906. Recognizing the growing need for a church north of downtown, the First Baptist Church of Atlanta organized, planned and mostly financed the Ponce Baptist endeavor. Before the Ponce de Leon Baptist Church building was built, the members (80 percent of whom came from First Baptist) met in a temporary building across the street on Edward Peters's land for about a year. By the late 1920s, when Ponce was becoming an apartment-lined commercial corridor, Ponce de Leon Baptist sold the building to Central Congregational Church, which has since moved to Clairmont Road in Decatur, Georgia. The Ponce de Leon Baptist congregation constructed a new building northward in Buckhead in 1930 and absorbed Buckhead Baptist Church. In 1932, Ponce de Leon Baptist and Second Baptist merged to form Second-Ponce de Leon Baptist Church, and it continues with that name in its Buckhead location today. The church building on Ponce was demolished around 1968, and a gas station and convenience store occupy the lot now.

From 1922 to 1953, Westminster Presbyterian Church held services in a brick building on the southeast corner of Ponce de Leon and Boulevard. Originally, the church was located on the corner of North Boulevard and Forrest Avenue, but it was destroyed in the Great Fire of 1917, during which 75 percent of the church's congregation lost their homes. The famous Scotch minister Peter Marshall (1902–1949) was minister of this church from 1933 to 1937. He was so extremely popular with Atlantans, and particularly with the college-aged ones, that the church had to be enlarged. The deacons often stood on the sidewalk and listened to him through the open windows of the church. His widow, Catherine, wrote his biography in 1951, *A Man Called Peter*, which was a bestseller and made into an Oscar-nominated film in 1955. Catherine Marshall wrote many other books, including the bestseller *Christy*. In 1953, the church moved to its present location on Sheridan Road in northeast Atlanta.

On the south side of Ponce on a hillside between Argonne Avenue and Hunt Street was once a school named the North Avenue Presbyterian School (NAPS), later evolving into being called the Napsonian School. It began in 1909 at North Avenue Presbyterian Church (still located on the southeast corner of North Avenue and Peachtree Street) when its membership and minister desired to have a school for their children that would also provide biblical instruction. The first class had twenty pupils and one teacher. By 1920, the school had grown so that the church was able to purchase a large lot that fronted three hundred feet on Ponce and had two residential houses built on it. The school constructed several additional buildings over

the next twenty years, including a library and a gymnasium. In the interest of becoming a college preparatory school, the school changed its name to the Westminster Schools and moved to Paces Ferry Road in the Buckhead portion of Atlanta. The Washington Seminary private school that had been located on Peachtree Street merged into Westminster in 1953, and this excellent school continues to flourish today.

The Presbyterian Center was built on the site of the Napsonian School after the Presbyterians had operated out of the old school campus for a time. It was designed by the Atlanta architectural firm of Ivey and Crook in 1950, but the building was not constructed until 1966. Ernest Daniel "Ed" Ivey

Top: The Napsonian School's basketball team is shown here in the 1920s. Notice the initials "NAPS" on the ball.

Bottom: About 1920, some of the students pose outside the Napsonian School's new facilities on Ponce, which were originally private residences.

This 1940s postcard depicts the Napsonian School after it had built additional buildings on the lot.

and Lewis Edmond "Buck" Crook are known in Atlanta for their traditional neoclassical building designs and, specifically, the four-columned portico, evoking a classic southern Colonial look. The Presbyterian Center was a departure from that style. Some of the many other buildings designed by Ivey and Crook around Atlanta are the First Baptist Church in Decatur, Wieuka Baptist Church in Buckhead, Druid Hills High School, the Crum and Forster building at Georgia Tech and the Druid Hills United Methodist Church on Ponce de Leon Avenue.

Grace United Methodist is another church that moved to Ponce de Leon Avenue after the Great Fire of 1917. The church began in 1871 as St. John's Mission and changed its name to Grace twelve years later; the origin of the name is unknown. After moving from a couple of locations, the church built at Highland Avenue and Boulevard in 1906. When the Great Fire decimated the church building (and the homes of 90 percent of its members), the church purchased land on Ponce de Leon Avenue for $11,000, which was the insurance proceeds from its burned building. The fire also destroyed the church's pipe organ, which had been on display at the 1895 Cotton States and International Exposition in Piedmont Park and had been in the church's possession since 1896. The Sunday school building was first built on the Ponce site in 1918, and in 1923, the congregation raised enough funds to build a beautiful gothic sanctuary,

which stands today. A great period of growth occurred in the church under the leadership of Dr. Charles Allen; five thousand new members were added during his tenure from 1948 to 1960. The street to the west of the church is named for him. Grace Methodist continued to grow throughout the 1950s with the addition of more land, enlarging the sanctuary and a new Sunday school building. Grace United Methodist Church is an example of a church that has adapted to its circumstances over the years and continues to succeed on Ponce. It is located on the old antebellum Medlock property, and it is believed that the spring used by the Medlock family can still be found flowing behind the church.

Francis Palmer Smith (1886–1971), one of Atlanta's most esteemed architects, designed the sanctuary for Grace United Methodist and another gothic Ponce de Leon church sanctuary as well: the sanctuary of Druid Hills

Grace United Methodist Church's sanctuary was built in 1923. The church moved to Ponce after its building was burned in the Great Fire of 1917.

Presbyterian Church, which was erected in 1939–40. Smith was Georgia Tech's first director of architecture and was a draftsman for Atlanta architect W.T. Downing. At Georgia Tech, Smith taught and influenced many other Atlanta architects, such as Philip Shutze, Ed Ivy and Lewis Crook. After his time at Georgia Tech, Smith went into private practice with Robert Smith Pringle, forming the Smith and Pringle architectural firm. In Atlanta, the team designed—along with other houses, churches and commercial buildings—the Cox-Carlton Hotel, the Rhodes-Haverty Building, the Norris Building and the William-Oliver Building. After Pringle's retirement, Smith continued designing primarily churches, one of which is the Cathedral of St. Philip on Peachtree Road in Buckhead.

Druid Hills Presbyterian, located on the north side of Ponce de Leon Avenue, about a block west of Ponce's intersection with North Highland Avenue, was established in 1883 as the Fourth Presbyterian Church. By 1910, the church had been renamed Druid Hills Presbyterian and was situated on the northeast corner of North Highland and Blue Ridge Avenues (currently a parking lot, one block from Ponce). The church recognized the need to move and grow as Ponce and all the northeast side of Atlanta were experiencing a time of prosperity in the early 1900s. In 1917, its minister, Daniel M. McIver, inspired his congregation to grow with words that describe the desirability of the Ponce de Leon Avenue area at that time:

> *This splendid, growing, prosperous section of our great city expects and demands a church edifice that will be a credit to our community…our strategic location is a challenge that we have been brought to the Kingdom for this great service. Our people, homogenous yet cosmopolitan, conservative but progressive, united and harmonious, challenge us to be equal to this unrivaled opportunity for advancement. Our church challenges us to put forth our noblest efforts for humanity.*

The church did grow and bought its Ponce de Leon Avenue property from one of its members, Dr. Lucian Lamar Knight, with generous financing. Knight—historian, journalist, minister, author, orator and lawyer—established the Georgia State Archives as a repository for the state's historic documents and information. He was Henry W. Grady's cousin and an editor at the *Atlanta Constitution*. Druid Hills Presbyterian's first services in new buildings on Ponce were held in 1924, and in 1940, the new sanctuary designed by Francis Palmer Smith was completed. The church has continued to reach out to the community with a spirit of hope and

Druid Hills Presbyterian Church's sanctuary was designed in 1939 by architect Francis Palmer Smith.

assists many philanthropic endeavors. The Presbytery of Greater Atlanta's headquarters is located adjacent to the church on its property.

Druid Hills Baptist Church's beginnings were in the neighborhood of Virginia-Highland at Highland Park Baptist Church on the corner of North Highland and Greenwood Avenues. Its charter was granted in 1914 with 173 members, many of whom came from the dissolved Highland Park church. In 1918, Druid Hills Baptist Church bought a lot on the southeast corner of Ponce and North Highland Avenue, and while it has purchased surrounding property over the years, the church has remained in that location. It first met in a temporary structure on the property, and the church began to flourish, so that in 1928, the congregation held its first service in the magnificent Beaux-Arts sanctuary that stands today. The sanctuary was designed by the architectural firm of Dougherty and Gardner of Nashville, Tennessee. Edward Bennett Dougherty (1876–1943) was a native Atlantan and had trained at the École des Beaux-Arts in Paris. Primarily, he is noted as a church architect in Atlanta, Nashville and other southern cities. Dougherty also designed the Imperial Hotel and the First Church of Christ Scientist, Atlanta, both of which are on Peachtree Street.

Dr. F.C. McConnell was Druid Hills Baptist Church's first minister. He led the church from 1914 until his death in 1929. Dr. McConnell's home was on Ponce de Leon Avenue, and his last words were actually spoken in a car on Ponce at North Highland Avenue. He pointed from the car to the church and said, "God's house, God's people, God's program. For God so loved the world…that he gave…"

The second minister of the church was Dr. Louie D. Newton, who served the church for four decades. Dr. Newton was often referred to as "Mr. Baptist," for he held every elected office in his denomination and was an abundant writer and speaker. He was instrumental in bringing the 1939

Congress of the Baptist World Alliance to Atlanta and, ultimately, to Ponce de Leon Avenue at the ballpark. Tens of thousands of people came to the Ponce de Leon Ballpark that week for services. Dr. Newton had arranged the venue and even convinced the passing train engineers not to blow their whistles at the crowd. One of the meetings contained more than thirty thousand people—all at the park. An *Atlanta Constitution* article on July 18, 1939, described the crowds at Ponce de Leon Ballpark:

> *The commodious stands were filled and the temporary seats on the field were banked solidly with humanity. Costumes ranged from the normal American summer wear to the distinctive pajama-like garments of Chinese women and the flowing garb of men of India. There was every shade of coloring, every cast of countenance, every racial feature, among the ranks of the seated thousands. Atlanta, at that instant, was a world capital.*

This church conducted the first vacation Bible school in the Atlanta Baptist Association in 1923 and the first coed Sunday school classes, and in 1937, it built the first modern church library in the Southern Baptist Convention. The church sanctuary was air conditioned for the first time in 1954. In the 1950s, the Atlanta Crackers baseball team was known to appear at Druid Hills Baptist on Easter Sunday—in their uniforms but wearing regular shoes and not cleats. Many of the large shrubs planted around the church were gifts from Sunday school classes over the years; some of them are half a century old. Druid Hills Baptist has completely adapted to the diverse Ponce de Leon Avenue community of today, from providing help to international refugees to feeding Atlanta's homeless.

On the northeast corner of Ponce and Briarcliff Road is Druid Hills United Methodist Church. It was built on John Slaughter Candler's lot, which was the first lot upon which a house was built in Druid Hills. Candler was a founding member of the church and made the lot—4.2 acres—available in 1946. Previously, the church had been located on the corner of Blue Ridge and Seminole Avenues. It began in 1900 as a small mission on North Highland Avenue called Copenhill Mission, moved to Blue Ridge and Seminole Avenues in 1912 and finally opened on Ponce in 1955. The architect of the church was Ernest Ivey of the famed Ivey and Crook architectural firm. Ivey was a member of the church. Andrew Carnegie helped purchase the church's pipe organ in the early 1900s, and that organ and the church were remodeled in 1998. Besides its missions, food pantry and other excellent works on Ponce de Leon Avenue and

Shown here is a temporary structure used by Druid Hills Baptist Church before the church built its permanent sanctuary. This temporary building was constructed in 1918 on the southeast corner of Ponce de Leon and North Highland Avenues.

This postcard depicts Druid Hills Baptist Church about 1940.

beyond, the church opened a day care in 1982, which is still operating. The day care, Druid Hills United Methodist Preschool (DHUMP), is a beloved member of the community and has educated many of the young children of the surrounding historic neighborhoods.

Between Briarcliff and Springdale Roads on the northern side of Ponce is the Springdale Park Elementary School, or "Spark," as it is known by the locals.

Two historic houses—known now as the Rutland Building and the Hirsch House—and a third, newly constructed building, the Olmsted Building, make up the school. The Rutland Building was designed by Atlanta architect Joseph Neel Reid (1885–1926) in 1913 as a private residence. Reid was Atlanta's premier home designer in the early 1900s, and his Colonial Revival designs were and continue to be some of the most sought-after houses in the city. In his early career, Reid worked for architect Willis F. Denny, who is best known for designing Rhodes Hall and St. Mark's United Methodist Church on Peachtree Street, Inman Park United Methodist Church and the Victor Kriegshaber House (the "Wrecking Bar") on Moreland Avenue. Reid attended the École des Beaux-Arts in Paris, France. Neel Reid also designed commercial buildings and apartments. The Hirsch House was designed by Martin Nicholes around the same time period that the Rutland Building was designed.

Two prominent Jewish families lived in the houses in the early twentieth century. The Phillips family lived in the Rutland Building with their children for many years. The house had been designed by Neel Reid for Atlanta lawyer Benjamin Z. Phillips and his wife, Nettie, in 1913. Nettie's father, Jacob Elsas, lived with them as well. He was a German immigrant who founded and owned the Fulton Bag and Cotton Mill. At one time, the mill employed more people than any other company in Atlanta. Elsas was a major donor to Georgia Tech, the Hebrew Orphans' Home and Grady Hospital. In the Hirsch House, as described in the 1930 federal census, were Jacob N. Hirsch, his wife Tillie, their son Samuel, his wife Dorothy and their child.

In 1979, the Howard School, which is a school for children with language learning disabilities and learning differences, bought the Rutland Building and used it for its campus until it sold the building in 2007 to the Atlanta Public Schools. The Howard School is now located on Foster Street in northwest Atlanta. Prior to the Howard School's purchase of the Rutland Building, the home had been used as a rooming house for telephone operators.

Springdale Park Elementary School's third building—a newly constructed building attached to the Rutland Building—is a LEED (Leadership in Energy and Environmental Design)-certified building. This "green" design provides a healthier learning environment for the children and can only be achieved by the school's advancements in rigorous construction and sustainability standards. It is the Atlanta Public Schools' first LEED-certified school.

A few less commonly known religious edifices are located in the Druid Hills section of Ponce de Leon Avenue. The Atlanta Hare Krishna Temple and the Atlanta Primitive Baptist Church are both located on South Ponce de Leon Avenue. A Church of Jesus Christ of Latter-Day Saints (Mormon)

temple is located on the northern side of Ponce de Leon Avenue between Oakdale and Lullwater Roads and across from the Oakgrove section of the Olmsted Linear Park. It was built in 1952 and is the oldest existing Latter-Day Saint church building in Atlanta.

On the south side of the Oakgrove section of the Olmsted Linear Park is the campus of the Paideia School. This private pre-kindergarten-through-twelfth-grade institution was established in 1971 and has quickly risen to become one of Atlanta's best private schools. The campus encompasses over a dozen buildings, many of them formerly private homes, and almost one thousand students are enrolled. The building at 1341 South Ponce de Leon Avenue was designed by Neel Reid for Frank Adair, son of Forrest Adair, whose real estate company finished the development of the neighborhood of Druid Hills. That house is now used as a classroom facility for pre-kindergarten classes.

St. John's Lutheran Church, located on the northeast corner of Ponce and Oakdale Road, was once the home of Samuel Hoyt Venable—one of the famed Venable brothers of the Venable Brothers Contractors who owned Stone Mountain and an on-site quarrying company in the late nineteenth and early twentieth centuries. Quarrying the mountain's "white gold," as the granite was called, made two thousand feet of street curbing and 200,000 blocks of paving stone per day during the company's peak production years. The granite from Stone Mountain has been used on the steps of the U.S. Capitol Building, the vaults of the U.S. Treasury building, Fort Knox, the locks of the Panama Canal and on buildings as far away as Tokyo. The Venable name is inextricably linked to the history of Stone Mountain and to the granite scattered throughout Atlanta in the streets, houses and churches. Unfortunately, Samuel Venable's name is also linked to the Ku Klux Klan in Atlanta. He was involved in the 1915 revival of the Ku Klux Klan and granted an easement of the top of Stone Mountain to the Klan that continued until 1958.

Paradoxically, the St. John's Lutheran Church has turned Samuel Venable's house into a place of beauty, peace and shelter to Atlanta's people of all races and religions. The house, which was bought in 1959 for about $60,000, has been lovingly restored, and the new additions to the church have been thoughtfully incorporated into the house. The church congregation was first established in 1869 and is the oldest Lutheran church in Atlanta. It was originally located downtown and then occupied a church building in the nearby neighborhood of Inman Park before finally purchasing Venable's mansion.

The house was built in 1914, and Samuel lived there with his sister Elizabeth, his brother-in-law and their children. He never married and is buried at Atlanta's Oakland Cemetery. As with Druid Hills Baptist Church's building, the architect was Edward Bennett Dougherty. Of course, the house is constructed with Stone Mountain granite. The interior of the church still retains the look of a residential home while at the same time clearly appearing to be a church. Throughout the mansion are clues of its past, such as the Venable family's crest and coat of arms, inscriptions of the family motto and, most striking, decorative painting done by another one of Venable's sisters, Leilla Venable Ellis. In 1969, the church added the sanctuary building, which is located in front of the mansion, close to Ponce; it is octagonal in shape. Near to Ponce de Leon Avenue is a large stone planter that was previously located where the sanctuary is today and was a fountain. The church is involved in many philanthropic missions and opens its doors for shelter to the less fortunate individuals of Ponce.

Next door to the Venable mansion is another old mansion that has also been converted into a church: the St. John Chrysostom Melkite Catholic Church (hereafter "St. John"), a Middle Eastern church that practices in the Greek ritual tradition. The mansion was built in 1916 by Coca-Cola Company founder Asa Griggs Candler. It was the last house that he and his wife, Lucy, lived in before their deaths. Lucy died in 1919 of breast cancer, and Candler died in 1929, spending the last three years of his life with a protracted illness at Wesley Memorial Hospital, forerunner of Emory University Hospital. Asa Candler remarried after his wife's death, and it is said that his new wife, May Little Ragen, was never happy in the Candler mansion because of reminders in the house of Lucy, such as the "LC" carved in marble over the house's front door. Prior to living on Ponce de Leon Avenue, Candler lived in his native town of Villa Rica, on Seaboard Avenue near the neighborhood of Inman Park and on Elizabeth Street in Inman Park.

In addition to being a soft drink mogul, Asa Candler was a mayor of Atlanta and an extremely generous benefactor to the city, churches, schools and individuals throughout his successful life. The newspapers called Candler a "millionaire mayor on a four thousand dollar a year salary," meaning he was practically drafted to the position and did it out of a sense of duty and not for financial gain. However, Candler never shied away from naming anything after himself and became perturbed if his name was ever misspelled in the newspapers. Throughout his life, Asa Candler devoted himself to his family and to the Methodist Church. Among many other

Samuel Hoyt Venable built the granite house in the background in 1914, and it and the octagonal building in front of it are now the facilities of the St. John's Lutheran Church.

The Venable family's library is shown here in 2011, now being used as part of St. John's Lutheran Church. Samuel H. Venable's sister painted the scenes from Stone Mountain in this room in the early 1900s.

philanthropic deeds, he donated the land between Ponce and Mclendon Avenue, now known as Candler Park, to the city in 1922, and he provided the original funds to start Emory University, an outreach of the Methodist college Emory at Oxford. Asa Candler also worked in the real estate development business and built many houses in Inman Park and around the city. Candler, who obviously had good business sense, nevertheless funded 100 percent of a business venture with George and Forrest Adair, wherein the Adairs sold land for the Druid Hills neighborhood, yet Candler only received half of the profit. Although Candler often worked late in the evenings in his younger years because of his hectic schedule with the Coca-Cola Company, his children were a priority to him, and he was involved with their affairs as children and as adults. He was known for his efforts in taking care of extended family members, from being at their sides during illnesses to providing financial help. Upon his death, Asa Candler's body was laid out in the Ponce house according to the meticulous plans he had made regarding his funeral arrangements. He and members of his beloved family are buried at Westview Cemetery; the monuments were made to look like pillows to represent the idea that the family is not dead but only sleeping.

Candler built the house after a trip to Italy, and it is modeled on an Italian villa. The mansion is a one-story house because Lucy's severe arthritis issues made stairs difficult for her to climb. The most memorable feature of this house is the central atrium-turned-sanctuary, which was originally thirty-five by sixty-five feet with a pink marble and mosaic floor and leaded-glass ceiling. St. John has altered the room slightly by raising the floor and removing some of the sixteen original columns to accommodate the pews and to allow for a clearer view. The dining room at the north end of the atrium is now an altar. Originally, four bedrooms opened off the atrium, but now a hallway encircles the atrium, allowing those rooms to be separated from the sanctuary and to be a residential area for the priest. In the front of the house, the original music room and library are still intact with the original woodwork, Czech glass and mahogany bookshelves; now they are used as the church's Heritage Room and gift shop. Like Venable's house next door, the inside of the mansion still looks like a house while maintaining the look of a church.

The bricks, the door hardware and other accoutrements of the house came from the home of James W. English Jr., formerly located at Peachtree and Prescott Streets. His father, James W. English Sr., was mayor of Atlanta from 1881 to 1883, a banker, a railroad builder and the owner of the Chattahoochee Brick Company. The brick company has been exposed in

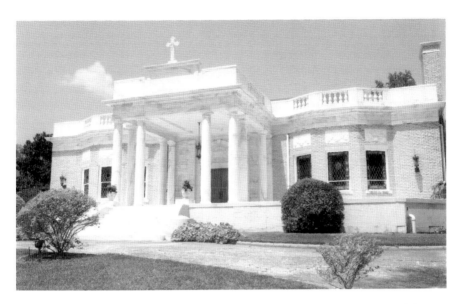

Asa Griggs Candler, founder of the Coca-Cola Company, built this house in 1916. It is now being used as a church by the St. John Chrysostom Melkite Catholic Church.

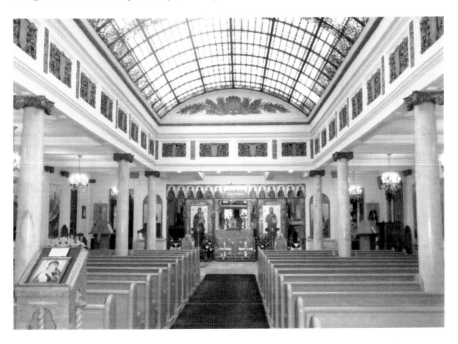

The sanctuary of the St. John Chrysostom Melkite Catholic Church can be seen here. When Asa Candler owned the house, the room was a sunken atrium. The leaded-glass ceiling is original.

recent years as a proponent of post–Civil War slavery, where men were bought, sold and harshly punished well into the 1900s. As the company was a large producer, the bricks are still all over Atlanta today. The yellow bricks at St. John are most likely from the Chattahoochee Brick Company as well, considering their provenance.

St. John Chrysostom Melkite Catholic Church purchased the mansion in 1955 from the American Legion, which had intended to use the house as a headquarters and a war memorial but never did realize its intentions. From the time Asa Candler's second wife, May, and her twin daughters moved out of the house—which was shortly after Candler's death—to the time the American Legion bought it in 1946, the house stood empty or was rented out and even used as a boardinghouse, with fifteen tenants. Today, the church is bustling with activity, providing religious guidance to its members, as well as sharing its historic facility with the community.

Chapter 4

JOY IN WORK

As Ponce de Leon Avenue changed from a residential area to a commercial corridor, more and more businesses began to open their doors on the avenue. Houses were torn down and replaced by office buildings. Some houses were actually changed into places of business. Big corporations such as Ford Motor Company and the Sears, Roebuck Company planted deep roots on the street. Grocery stores, pharmacies, restaurants, real estate brokers, insurance companies—virtually every kind of commercial enterprise—hung signs on Ponce. The streetcars traversed Ponce de Leon Avenue until well into the 1940s, and because Ponce was part of six highways, thousands of cars began to race down the wide street daily. It became a busy place, but it was not a place people lived anymore; it was the kind of place where people made a living.

In 1946, Samuel M. Inman's house, on the southwest corner of Ponce and Peachtree Street, was demolished to make way for the Franklin Simon Department store, which operated there about thirty years. The demolition occurred shortly after Inman's wife's death. Originating in New York in 1903, the department store chain was actually a collection of specialty shops under one roof. It declared bankruptcy in 1979 and closed its forty-two stores. There is a parking lot on the corner today.

The master of modern architecture, Ieoh Ming Pei, designed the marble-walled, box-like structure on the southeast corner of Juniper Street and Ponce de Leon Avenue in 1949. This office building—the Gulf Oil Building—was possibly I.M. Pei's first successfully built design; there is some dispute as to

whether the Helix Building in New York City was the first. Regardless, the Gulf Oil Building is a design that the modernist master first cut his teeth on when he was young and seeking to prove himself as an architect. Pei was born in China in 1917 and moved to the United States when he was eighteen years old. He was educated well at the Massachusetts Institute of Technology and the Harvard School of Graduate Design. During his long career, he has designed numerous institutional projects, including the Pyramide de Louvre in Paris, France; the Rock and Roll Hall of Fame in Cleveland, Ohio; and the East Building of the National Gallery of Art in Washington, D.C. Pei's designs are known for their sleek angles, abstract form and sophisticated designs that are devoid of ornamentation. His designs favor steel, glass, stone and concrete as construction materials and tend to be in harmony with the natural environment.

A building permit for the Gulf Oil Building was applied for in May 1950, listing Henry C. Beck Company as the builder with an estimated cost of $200,000. The building was completed in 1951. It has been called the Crawford and Company Building and the 131 Building, although the Gulf Oil Building is its most commonly known name. In the 1930s and 1940s, a gas station operated on its lot, owned by the Gulf Oil Corporation. The building is threatened with demolition now and is on the market for sale.

Between the Gulf Oil Building and St. Paul's Presbyterian Church is an office building that was once operated by JCPenney. In 1960, the department store company demolished the Sunday school building built by the Faith Memorial Church in the 1950s and built the office building for about $150,000. It is currently empty and on the market for sale.

On the southeast corner of Ponce and Myrtle Street is a building known as the Woodruff Inn. Rumors about the building abound. Allegedly, a woman named Bessie Woodruff ran a brothel from the building in the 1960s and, possibly, for a couple more decades. "Miss Bessie's" was known to be a respectable establishment of its kind; the women wore their church dresses to work and were polite. The rumor is that many of the women in Miss Bessie's employ were married and traveled into the city for two days at a time to make some quick money. Like other places on Ponce, it is rumored that infamous gangster Al Capone spent the night there. Today, the building is a hostel (a dormitory-like hotel) catering to traveling international students. The Atlanta Hostel opened in 1991 and claims to be the first hostel in the city. Despite yet another rumor that the Victorian turret roof cap in the front yard came from the demolished Terminal Station, the current owner bought it from a flea market for use as garden décor.

In 1966, the Napsonian School buildings were replaced with this building, designed by the architectural firm of Ivey and Crook. It is now being used as an infectious disease center.

As discussed in chapter three, the residential houses on the south side of Ponce between Argonne Avenue and Hunt Street became part of the Napsonian School, and then the Presbyterian Center was built on that location in 1966. That same building, designed by the architectural firm of Ivey and Crook, still exists today but as part of Atlanta's Grady Health System. Founded in 1986, it operates as an infectious disease center, dealing almost exclusively with HIV/AIDS patients. The center treats five thousand patients a year; some come in every day for treatment, but most come in quarterly. Emory's Division of Infectious Diseases provides the staff. The center is federally funded, and pharmaceutical companies provide many of the medications free of charge. From the North Avenue side of the building, the old chapel for the Presbyterian Center can be seen; it now serves as an entrance foyer. The center is nationally known as a model for providing comprehensive, cutting-edge treatment to mostly impoverished patients.

The two commercial buildings, located adjacent to each other on the northeast corner of Argonne Avenue and Ponce de Leon Avenue, are

perfect examples of Ponce's evolution from antebellum farmland to urban commercial development. Two houses, built on historic land, changed from residential to commercial over the course of the twentieth century. The house on the corner is known to modern Atlantans as the Kodak building because of its large rooftop sign, while the house immediately to the east is known as home to the Atlanta Eagle nightclub; hereafter, the buildings will be referred to by those names—the Kodak building and the Atlanta Eagle building—for clarity.

In 1883, the land that had originally belonged to antebellum landowner John Williams Medlock was platted for development, and William Arnold Hemphill (1842–1902) bought some of the lots in 1888 as an investment. Hemphill was one of the 1868 founders of the *Atlanta Constitution*, and he was mayor of Atlanta from 1891 to 1893. One of the lots that Hemphill bought was the lot that now hosts the Kodak building and the Atlanta Eagle building. A spring—Silver Spring—flowed northward through the lot, originating from an area that would now be in the middle of the parking lot behind the buildings. In 1898, Hemphill gave the lot to his daughter, Lula Belle. She and her husband, lawyer L.D. Teackle Quinby, were living in a house on the lot by the issuance of the 1899 Atlanta City Directory. This Quinby house is the Atlanta Eagle building. In 1905, Lula Belle Quinby sold the lot and house to William L. Hancock Sr. (1871–1940).

William and his wife, Virginia, first lived in the Atlanta Eagle house for five years with their two sons, Kerfoot and William Jr. The father was known as Will, and the son was known as Bill. The Hancocks built the Kodak house next door to their first Ponce house in 1910 and moved into it that same year, renting out their old house. Within a couple of years after Virginia's death in 1922, Will moved around the corner directly behind the houses into a brick apartment house, where he lived until his death. The Hancocks were members of Ponce de Leon Baptist Church and were active in Atlanta's social society. Will Hancock, a native Atlantan, was a U.S. consulting engineer who supervised PWA projects at the end of his career but began his career in the private sector at the Winship Machine Company, where his father was superintendent. He went on to work for an agricultural company, supervising work in forty factories in the Southeast. Throughout his adult life, Will was active in the Atlanta Old Guard Battalion. The Hancock men died tragically. Kerfoot and Bill had always been extremely close brothers, playing together as boys on Ponce and then keeping in close contact as adults. In 1939, Bill died in a car accident between Atlanta and Augusta. One week later, Kerfoot died in Los Angeles, California; he had been suffering from

a weak heart for many years, but it was believed the loss of his brother hastened his unexpected death. Within a year, their father—the strong PWA engineer and supervisor—had retired and died in a private hospital.

In the mid-twentieth century, Pappy Starns bought the Kodak building property, where he operated a business called Star Photo. Outside the Kodak building's front door on Ponce is written in cement the words "Star P 1953," which was done at the time the storefront was added to the Ponce side of the house. In the 1970s, Starns sold his business interest to Ritz Camera (a predecessor to Wolf Camera), and he sold the real property to Alan F. Goodelman (1931–1997). When the lease ran out for Ritz Camera, Goodelman moved one of his camera shops—called Alan's Photography—into the building. In 1979, Goodelman applied for and received a permit for a six-foot by twenty-four-foot sign "on a steel frame on top of the building." Alan's Photography continued in the building until about 1987, when Goodelman sold the business; however, he opened up a small camera store in the building in 1992. Five years later, Mr. Goodelman died inside the store while printing photographs.

In 2001, former mayor Shirley Franklin used the Kodak building as her campaign headquarters, and the building has been relatively empty since that time. The building is in extreme disrepair and is currently on the market for sale. The Atlanta Eagle building has been a restaurant, a flower shop and for the last twenty-five years has hosted the nightclub.

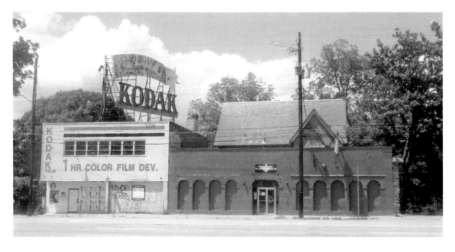

Two houses are hidden inside these commercial buildings on the northeast corner of Ponce and Argonne Avenue. The house inside the Kodak building on the left was built in 1910, and the house inside the Atlanta Eagle building on the right was built about 1899.

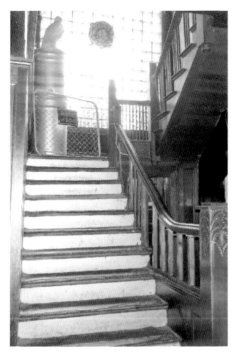

Inside the Atlanta Eagle building, the original staircase, dating from 1899, is still being used. Notice the eagle statue at the top of the stairs.

Small businesses flourished in the early and mid-twentieth-century buildings on Ponce de Leon Avenue. Today, some are in repurposed houses, like the Lucky Exchange clothes store on the northwest corner of Ponce and Myrtle Street, while others are in buildings that still retain vestiges of their original purposes. The shops on the northwest corner of Charles Allen Drive and Ponce remain basically unchanged in their appearance from when they were built in the early twentieth century and operate as a barbershop and two antiques stores. Just east of Grace United Methodist Church is a small shopping strip that retains its original look, but it is mostly unused. The Dee Kay office building, built in 1956 and located at 420 Ponce de Leon Avenue, is now a day care center.

The most iconic building of Ponce de Leon Avenue is the colossal Sears Building, located on the old Ponce de Leon Springs grounds between the railroad tracks and Glen Iris Drive. It is considered to be the largest brick structure in the South. Thousands of Atlantans have worked, shopped or ordered from this building, as it was once not only a large department store but also a catalogue distribution center for the entire southeastern United States. From 1990 to 2010, the building served as part of Atlanta's municipal system and was known as City Hall East. The city only occupied a small portion of the two-million-square-foot massive brick building. Jamestown Properties and Green Street Properties recently purchased the building from the city for $27 million, and it is slated to become a mixed-use urban development called Ponce City Market where Atlantans can live, work, shop, dine and play. A $180 million renovation is underway and is expected to be completed in the year 2014.

Back in 1926, when the Sears, Roebuck Company built this store, it was a marvel as well. The first spade of dirt was turned for construction on January 4, 1926, and the store opened on August 3, 1926—less than seven months later. The building, which has grown throughout the years, was originally 140 feet wide, 440 feet long and 232 feet high. It was ventilated by fourteen fan systems connected by over 250,000 pounds of sheet metal. The fire sprinkler system contained 75,000 feet of piping. There were 90,000 feet of piping in the plumbing and heating. The total floor space in 1926 was 750,000 square feet. Inside the store, there were thirty-five thousand different articles of merchandise for sale that had arrived via 250 train carloads. A pneumatic tube mail delivery system, using thousands of feet of steel tubing, operated from the basement and reached every corner of the store at lightning-fast speed.

The B-W Construction Company of Chicago—one of the largest construction companies in the United States at that time—constructed the building. Two thousand Atlanta workmen constructed the building and were paid $2 million in wages. The building crews worked day and night, twenty-four hours a day. When one crew went home, another crew took its place, every day for six months. The previous year, Sears had built another massive store in Kansas City, Missouri, and it used the same construction supervisors when building the Atlanta store. These supervisors had mapped out every detail of construction, based on their knowledge from the Kansas City store, and thus were able to complete the Atlanta store in record time.

The George C. Nimmons Company designed the Sears Building on Ponce. Nimmons was a Chicago, Illinois architect who designed primarily for the Sears, Roebuck Company. He is known for his large-scale commercial and industrial building designs wherein he considered the impact of the design on employees, a novel idea in the early 1900s. For example, his designs often included groupings of windows to allow for more natural light; the Ponce Sears Building's windows are grouped into threes. Nimmons also designed mansions for Sears founder Richard W. Sears and Sears president Julius Rosenwald in 1906 and 1903, respectively. Many of his industrial designs still exist and resemble the Ponce de Leon Avenue Sears Building with their brick façades and towers. In Chicago, the Reid, Murdoch and Company Building (now the Central Office Building) greatly resembles the Ponce store.

On the opening day of the store in 1926, thirty thousand people came through its doors; it was the greatest opening day in Sears's history at the time. There were drenching rains and storms all day. The mayor, Walter A. Sims, and Sears management personnel climbed to the top of the tower,

and the mayor himself hoisted the American flag to the top of the sixty-foot flagpole in the windy storm while thousands cheered from the street, hundreds of feet below the tower. The store opened with most of its twelve hundred employees at 7:00 a.m. By 1:00 p.m., over nineteen thousand people had entered the building. Four thousand mail orders were received on the first day. Hundreds of flower bouquets from friends of the company were spread around the store. Hanging baskets, filled with ferns and moss, were hung throughout the store.

While it is difficult to imagine a store with such a large capacity, it is interesting to note for future occupants of the building exactly what was located on each floor. The partitions that separated the various departments in the store would have equaled more than a mile in length if lined up side by side. On the basement floor was a cafeteria and dining room for customers and the employees, an office supply department for the employees and stoves and paints on display for sale. The first floor of the store contained almost every one of the thirty-five thousand articles offered for sale by the company on display with the most modern store fixtures and lighting available at the time. Headquarters for the fire marshal and the watchmen were also located on the first floor. Clerical offices, as well as cashiers' offices, were on the second floor, along with the bookkeeping, auditing, timekeeping and traffic departments. The third floor hosted the offices for the store's general manager and the departments for furniture, sewing machines and washing machines. On the extreme south end of the third floor were the adjoining tracks of the Southern Railway (formerly Air Line or Beltline) and headquarters for receiving. The railroad tracks were on the exact level of the floors, and all incoming orders were taken in here. Sixteen carloads of merchandise could be put on the unloading platform at one time.

The fourth floor contained the headquarters for the operating superintendent of the store and stocks of hardware, farm implements, harnesses, cream separators, gasoline engines and roofing, plumbing and heating supplies. On the fifth floor were drugs, toys, china, dinnerware, linens, notions and lighting fixtures. The tower portion of this floor contained the offices for the general merchandise manager. The sixth floor held books, jewelry, silverware, musical instruments, pianos, photographs, dry goods, silk, draperies, blankets and window shades. The seventh-floor tower hosted the offices for the local advertising manager, and on the rest of the seventh floor were sporting goods, radios, automobile tires and accessories and shoes. The eighth floor held women's and children's clothes, and the ninth floor held undergarments and hosiery and men's clothes. A doctor's office was located in the tenth-floor tower,

where employees were examined before they were hired and where they were treated in emergencies. The eleventh-floor tower area contained the offices for the Sears, Roebuck Company Agricultural Foundation.

Outside the main building were a separate power plant building at the rear of the store and a shipping room, which adjoined the main Sears Building. The shipping room was the largest room under a single roof that Sears had ever built up to that time.

Sears made itself part of Southern culture by gaining the trust of its customers through philanthropy and high business standards. Many tales are told throughout American culture of this company that stood behind its products. The customer was always right at Sears and felt appreciated by the company. Customers felt comfortable writing to Richard Sears himself with praises of his products or complaints about minute details with their catalogue orders. One of the ways the Ponce Sears store endeared itself in the state was with the farmers' market it opened in 1929 on the North Avenue side of the building. More than any other group of Americans, farmers had come to depend on Sears; it was their link to the outside world for merchandise and for farming and marketing information. Farmers traveled from all over the state to Ponce de Leon Avenue, where they could sell their goods on Tuesdays, Thursdays and Saturdays. It was not unusual for farmers from twenty Georgia counties and fifty county agricultural agents to be present at the Ponce Sears farmers' market. Until it closed in 1947, the farmers' market typically carried over fifty agricultural products— from seasonal fruits and vegetables to chickens and butter.

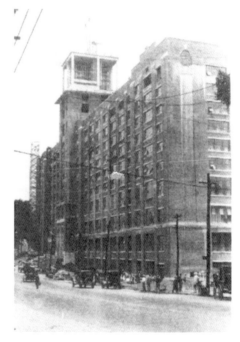

The Sears department store on Ponce closed in 1979, but the building continued to house a Sears regional office until 1987. Two-thirds of the building was never used by the city when it owned it from 1990 to 2011,

The Sears Building was under construction in this 1926 photograph.

leaving the offices somewhat frozen in time. Old time cards, rolodexes, machinery, hundreds of desks and shelves, antiquated office supplies and papers filled the building. The Sears Building is adjacent to the Atlanta Beltline, a multibillion-dollar transportation project that is in the process of being built and that will link the city's historic neighborhoods through a series of parks and development. The Beltline follows twenty-two miles of old railroad tracks that encircle the city of Atlanta, including the railroad tracks that once ran beside the third floor of the Sears Building. The future is bright for the old Sears Building; it is growing and changing to meet the modern needs of Atlantans.

In 1998, the Sembler Company purchased and developed the Midtown Place Shopping Center, located across the street from the Sears Building, between Lakeview Drive and the railroad. The first real development on the site was the four-acre lake built there in 1890. In 1907, the lake was drained and the spot became home to the Atlanta Crackers baseball team until 1965. Prior to the Sembler development, a group of Asian investors bought the land and built a shopping center called the Great Mall of China. As the Midtown Place Shopping Center, this historic spot is anchored with a Home Depot store and a Whole Foods store, drawing thousands of locals to the area daily.

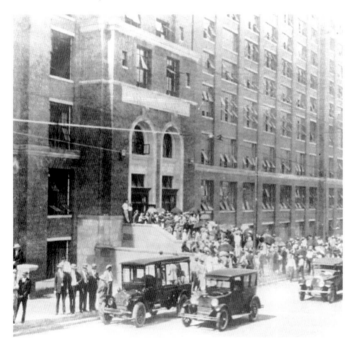

Opening day was August 3, 1926, at the Sears Building. Thirty thousand people entered the store on that day.

The Midtown Shopping Center once contained a man-made lake and, later, the Ponce de Leon Ballpark. The famous magnolia tree—the only tree ever considered "in play" in professional baseball—is still alive on the right in this 2011 photograph.

The Ford Motor Company of Detroit, Michigan, bought a lot on Ponce de Leon Avenue in 1914 from John S. Owens for $25,812.52. Owens was a wealthy investment banker and lived on Eleventh Street in Atlanta. On the lot, the company built a plant that became its southern headquarters, southeastern distribution center and an assembly plant and showroom that same year. The lot fronted 142 feet on Ponce and 785 feet on the tracks of the Southern Railway (previously the Air Line and Beltline Railways), which ran between the Ford Building and the Sears Building. This sale of land was reported at the time to be the first time land in Atlanta had ever been sold by the square foot. The building cost $500,000 to construct. It contained one acre per each of its four floors. Twenty thousand panes of glass were used in the building, using one pound of putty to place each pane. During construction, two men were electrocuted and died on the roof of the building while stringing an electric cable from across the street to the 50-foot tower atop the building. The Ford Company opened for business in this location in the middle of February 1915. On the first floor of the Ford plant was the showroom; it could be entered from the doors on Ponce. The rest of the building was used as offices, a shipping department and the assembly

plant. As many as eight freight train cars could enter into the building on tracks that ran through the second floor.

John Graham Sr. (1873–1955) was the architect for this and about thirty other Ford plants. He was originally from England and spent much of his life in Seattle, Washington. Graham's son, John Graham "Jack" Jr., followed in his father's footsteps, becoming an architect and later going into business with him. Jack Graham's most famous design is the Seattle Space Needle.

Henry Ford (1863–1947), founder and president of the company, and his engineers had recently invented the use of the moving assembly line or "assembling line," as it was called in those days. Previously, craftsmen had built the automobiles individually, with a maximum output of about twenty-five cars a day. But Ford wanted to provide every family in the country with a low-cost, rugged automobile—the Model T—and he wanted to supply his customers' demands. From there, mass production was born via the assembly line, and Ford could turn out a Model T every ninety-three minutes. On Ponce de Leon Avenue, Ford found its nexus of supply to the Southeast. The company could manufacture the parts of the cars in the North and ship the parts to Ponce, where they were unloaded from the train into the plant and assembled on the spot, thus saving shipping costs and providing faster output of automobiles.

Ford was a believer in hard work and ingenuity. He was good friends with Thomas Edison and valued new ideas, more so in his youth than in his later years. He had been obsessed with the idea of a horseless carriage since he was a boy and considered himself a "tinkerer" of machinery. After early attempts at the automobile with motorized goat carts and bicycles, he successfully built the Model A and convinced investors to start the company with him in 1903. In 1907, Ford had one factory and fourteen branches, but by 1914, he had seventeen assembly plants around the country and was producing the wildly successful Model T at a rapid rate. Ford hired tough supervisors, and assembling lines were likened to slavery; the turnover rate in Ford employment was high. He bought out his investors in 1919, and he became a tyrant of sorts after that, as he had no one to answer to about his actions at the company. Ford was also known for his anti-Semitism.

Henry Ford became involved in politics and started sharing his personal opinions about mankind through the media. He actually entertained the thought that he could stop World War I. While Ford was strong-willed and demanding, often to a fault, he was generous with his employees' salaries and with his property during difficult times. In 1918, he offered the use of all his factories and assembling plants to the U.S. government to use as it wished

during the war. The Ponce Ford factory was turned into a reclamation depot for army clothes and equipment during World War I. Several thousand women were employed in the Ponce building to repair items such as clothes, shoes and hats. During this time, the Ponce de Leon Ballpark across the street was turned into a tent city, where three thousand convalescent soldiers lived. While the soldiers regained their health from war injuries, they were taught occupations by the women in the Ford factory across the street so as to enable them to get postwar employment. During World War I, when the Ponce factory was not producing, Ford opened a parts department and repair shop in downtown Atlanta to service previously manufactured automobiles. In 1942, the U.S. Department of War purchased the Ponce Ford factory to use as a military induction center during World War II. It was later used as a storage facility for the U.S. Air Force.

Henry Ford's legacy to America is the assembly line for automobiles. He left Atlanta with an interesting building on Ponce. And he left the world many inspiring quotations:

> *There is joy in work. There is no happiness except in the realization that we have accomplished something.*
> *Whatever you have, you must use it or lose it.*
> *If I had asked people what they wanted, they would have said faster horses.*
> *History is more or less bunk.*

The last Henry Ford quotation listed here is seemingly ignorant, with no place in a history book; however, most historians believe Ford was misunderstood. He believed in recounting the history of the common people as well as the history of kings and wars. Ford wanted history books to give actual accounts of history and not only sanitized versions. For this, Ford—despite all his faults—should be praised by historians as a person who valued true history.

In 1982, the factory was remodeled and changed into an apartment building, now called the Ford Factory Lofts. The first floor on the eastern side is used as restaurants and office space.

Across the street from the Ford Building on Ponce is a street running northward named Ponce de Leon Place. This street, formerly named Main Street, runs adjacent to the Beltline and is east of the Midtown Place Shopping Center where the ballpark was previously located. The lot on the western corner of Ponce de Leon Place and Ponce de Leon Avenue was sold for $40,000 in 1922 by the McMillan estate for industrial

development. Two houses were on the property at the time of sale.

The man whose death had facilitated the land's sale for development was Ferdinand Dallas McMillan (1844–1920). Although his connection to this land adjacent to Ponce de Leon Avenue was brief, McMillan was one of Atlanta's most quirky historical figures and an example of a landowner who could see the possibilities of Ponce. In 1859, McMillan and his father had moved to Atlanta, and soon after, he enlisted in the Civil War as a drummer boy. As an adult, McMillan was a patent-holding inventor of agricultural machinery, a self-taught architect and owned a machinery company. He owned the

This advertisement for the Ponce de Leon Ford plant appeared in the *Atlanta Constitution* in 1915.

land at Ponce and Ponce de Leon Place, along with many other investment properties. McMillan is most remembered for being the owner and builder of Fort Peace, a house still located on Peachtree Street and Fifteenth Street, which many Atlantans simply refer to as the Castle. He built the Castle of his own design, carving its foundation into the side of the highest hill he could find in the area.

> *I had no architect, because I knew that I would borrow ideas from him, and I wanted no one's notions but my own. I intended to build a home that suited me, not someone else. Half the world lives a lifetime without ever doing what it wants to. Men and women become so used to imitations or so afraid of ridicule that they live out their lives borrowing ideas and expressions and habits, which before had been borrowed.*

This was the kind of businessman who bought property along Ponce de Leon Avenue in the late 1800s and very early 1900s—an original thinker who could envision the city's growth to the avenue. Men such as McMillan knew the land was ripe for picking, and many of them bought the rolling farmland to plat for residential development or to sell for industrial development.

Within two years after the sale of McMillan's lot on Ponce, a gas station (Texas Oil Company) and three small brick stores were built on the corner lot. Next to the corner lot, two brick industrial buildings were built soon after, hosting such businesses as the Frick Company (machinery sales), the Zachry Manufacturing Company (broom and mop sales), Zaban (moving and storage) and Charles Eneu Johnson and Company (printing). Today, the corner lot is not a gas station but a motorized scooter store, and the brick industrial building is an antiques store called Paris on Ponce.

On the western corner of Somerset Terrace and Ponce de Leon Avenue is a tattoo parlor, Liberty Tattoo, which occupies a building originally built in the 1960s to be a grocery store named Turner's Food Store. From Barnett Street eastward to North Highland Avenue, on both sides of Ponce, lots were platted to compose the Highland Park subdivision in 1893. This development of Highland Park continued in the early twentieth century. Many of the houses in Highland Park were designed and built by the firm of B.R. Padgett and Sons. The firm specialized in building houses, and it was at this firm that Atlanta female architect Leila Ross Wilburn apprenticed for two years before opening her own firm. Benjamin Robert Padgett Sr. (1850–1920) and his sons, Benjamin Padgett Jr. and Hardy, allegedly designed and built more homes in Atlanta than any other architects and builders before 1920. At the time of his death, Benjamin R. Padgett Sr. was the oldest builder in business in the city.

In 1947, the western corner of Ponce and Ponce de Leon Place hosted a gas station. *Courtesy of the Special Collections Department, Georgia State University.*

Today, the homes left along Ponce in the Highland Park area are mostly used for office spaces and small businesses. Some of the old houses were demolished in the 1930s and replaced with apartment buildings. The Open Door Community is in a repurposed apartment building on the northern side of Ponce de Leon Avenue. Founded in 1981, Open Door is a Christian community providing twice-weekly breakfasts and lunches, showers, clean clothes, medicines and worship services for homeless persons. The community is also involved in advocacy for social issues and provides a prison visitation and ministry program. Atlanta has thousands of homeless persons, many of them ending up on Ponce. Next door to the homeless community is a handsome brick, white-columned house, now being used as offices for a law firm. Doctors, real estate companies and other professionals also occupy a number of the old houses along Ponce in the Highland Park platted area.

A Publix supermarket replaced an A&P supermarket (which had been a Big Star supermarket), but long before grocery stores used the area on the south side of Ponce just west of Cleburn Terrace, this lot was platted for Highland Park homes. The 1911 Sanborn Fire Insurance map shows that only a few dwellings were built in the Publix lot at that time. However, an alley—Preachers Alley—ran through the middle of the lot, and the alley's path is still used today as the northernmost entrance drive into the Publix parking lot from Cleburn Terrace.

On the southwest corner of North Highland Avenue and Ponce is the Briarcliff Plaza Shopping Center, known as Atlanta's first true suburban shopping center because it was the first shopping center to be built with an attached parking lot in what was the bourgeoning era for automobiles. It was built in 1939 and retains its original Art Deco or Streamline Moderne appearance today. Like the Briarcliff Hotel (the Seven-Fifty) across the street, Asa G. Candler Jr. commissioned the building.

George Harwell Bond (1891–1952) of the architectural firm of Cooper, Bond and Cooper designed the shopping center and theatre. Bond was born in Lithonia, Georgia, and was educated at Georgia Tech and the École de Beaux-Arts in Paris. He had worked with architect G. Lloyd Preacher for thirteen years before partnering with the Coopers in 1928. Preacher is heralded for designing the Briarcliff Hotel across the street from the shopping center in 1925, but as they were partners at the time, it is likely Bond was involved in the hotel's design, as well as with some of Preacher's other designs. Bond also designed the Morningside Elementary School in 1934 and a Coca-Cola bottling plant. He and his wife, Constance, lived on

North Avenue for a period and then moved to Peachtree Road in Buckhead. He was a member of the Ponce de Leon Baptist Church.

The first businesses to open at the Briarcliff Plaza were Blick's Bowling Palace and the Majestic Diner, with the Plaza Theatre and Caruso's Dry Cleaning soon following. All of the businesses at Briarcliff Plaza except for the Plaza Theatre and the Majestic Diner have changed over the years. Plaza Drugs is indelibly ingrained in many Atlantans' minds when they think of Ponce de Leon Avenue. For the first few decades it was open, the drugstore, including its soda fountain, never closed and provided the city with the only opportunity for prescription medicines in the nights or on holidays. Plaza Drugs was operated by Rexall, Treasury Drugs and Big B Drugs. In the 1980s, the store was still in service but became somewhat shoddy and a hangout for the local panhandlers and the drug culture. Plaza Drugs closed in the 1990s, becoming a gourmet grocery store for a time. Now the Plaza Drugs site is home to a clothing store owned by a national chain.

Adjacent to Plaza Drugs was a Colonial Stores grocery store. Colonial was the product of two different food chains—one from Norfolk, Virginia, and one from Atlanta, Georgia. They combined in 1940 to form Colonial Stores with a headquarters in Atlanta, but the name was not used until after World War II. At its peak, the company owned five hundred stores in eleven states. In the 1970s, as a result of market competition, most of the stores belonging to the company converted to discount, no-frills grocery stores called Big Star, which survived in Georgia until 1992; all of the Colonial Stores had been sold by then. Colonial Stores premiered its self-service grocery stores in four states, including Georgia, and influenced supermarket development in many other states. The Ponce store delivered to local homes in the 1950s and 1960s.

About one block east of North Highland Avenue on the south side of Ponce is a retail business strip that has been in use since the 1930s. During the 1950s, the strip hosted two restaurants—the Seminole Grill and the Charles Restaurant—which are now used as antiques shops. A shop that sells, cleans and stores fur coats has operated in the strip since 1955.

The Kirbo Building, located on the south side of Ponce de Leon Avenue, about a block west of Moreland Avenue, is an office building that houses offices affiliated with the Carter Center, a nonprofit organization concerned with advancing human rights. The Carter Center and the adjacent Jimmy Carter Library and Museum are located about a mile away from the Kirbo Building at North Highland Avenue and Freedom Parkway. This office building was built in 1971. In 1990, the Carter Center purchased the

The Briarcliff Plaza Shopping Center is shown here in 1951. In the center is the iconic Art Deco sign for the Plaza Theatre. *Courtesy of the Special Collections Department, Georgia State University.*

building, and former president Jimmy Carter honored his longtime friend and supporter Charles H. Kirbo by naming the building for him. Kirbo, a lawyer, campaigned for Carter when he ran for governor of Georgia, served as counsel to him as president and worked as the executive director of the Carter Center board of trustees. The two men had been friends since the 1960s, and Kirbo was believed to have been Carter's closest confidant until his death in 1996. He was known as former President Carter's "one-man kitchen cabinet."

A PLACE FOR REST FROM TOIL

W hen Atlantans of recent decades think of Ponce de Leon Avenue, they envision entertainment. From Midtown Atlanta to the city limits, the street has been lined with theatres, restaurants, parks and bars, and it continues to host such amusements. In Atlanta's modern collective memory, Ponce is nothing but a highway lined with fun places, some of which showcase the underbelly of the city. Even historically, while the avenue was lined with prestigious mansions, its inception was fashioned around Ponce de Leon Springs—a place of play and rest.

Open-Air Entertainment

A terraced garden paradise once existed on the north side of Ponce between Myrtle Street and Argonne Avenue called Little Tyrol. It was built by Swiss landscape designer Julius Hartman in the late 1880s—just prior to the time he was hired by the Atlanta Street Railway Company to build a true park at Ponce de Leon Springs. The area where the 3½-acre garden was located was nothing originally but a deep, barren ravine—an eyesore to the residents of Victorian Ponce. Little Tyrol's lot was part of the 405-acre tract Richard Peters had bought in the 1850s, and his son Edward, who lived at Ivy Hall on Ponce, was desperate for someone to develop the unsightly hole so very near his home. Peters offered Julius Hartman any terms he desired to take on the property for development into a garden; Hartman bought it cheaply for

$3,000 with a generous payment plan. In those days, the idea of a German beer garden was just catching on in America, and Hartman intended to develop the ravine into such a garden area where he could serve beer under the trees in Bavarian style. Unfortunately, Hartman did not notice at the time of purchase that Edward Peters had sold the land to him with a covenant that no alcohol could be sold on the land. The beer garden was not able to happen; however, Hartman did build a park that he kept open to the public for years.

This region on Ponce de Leon Avenue where Little Tyrol was constructed was in the same area where the trolley bridge had been built in 1874 by the Atlanta Street Railway Company. The bridge ran along the same route as Ponce—virtually suspending the street in the air—and Little Tyrol would have been on the northern side of the bridge. The restaurant Mary Mac's Tea Room is in that location now and has been since around 1950. When Hartman developed the park, the county commissioners had already ordered the space under the bridge to be filled in with dirt so that a bridge was no longer necessary, but the fill-dirt created steep embankments on either side of Ponce, and a sewer line ran along the ravine and through the embankment. Hartman had quite a challenge on his hands, but he managed to create an exquisite garden that enhanced the view from the avenue and provided a setting for picnics and parties.

Little Tyrol's top terrace was on the western end and was level with Ponce de Leon Avenue, although it required a bridge to enter into the park. There were three springs in the park—chalybeate (containing iron), sulfur and freestone (arising from rain and gravity). Hartman planted the side of the steep embankment with grass and flowers. The best description of Little Tyrol comes from one contemporary to the park's existence; it was described in the *Atlanta Constitution* on September 25, 1892:

> *What a wonderful place it is! To observe it from the grand avenue it looks like a veritable dream of fairyland. Crossing a lovely ravine spanned by a graceful bridge the visitor finds himself on a magnificent site…looking to the south, grand oak trees spread their cooling shade all around. Near by the vineyard, the water lily pond and springing fountain to the east. Turning to the north, two charming little lakes are seen, in one of which stands a Japanese pavilion and all embowered in a world of beautiful, fragrant flowers. The shade trees here are truly grand, especially a magnificent beech. Really one must feel that Tyrol is a little kingdom in itself and the most beautiful in this world. What wonders has dame nature worked here.*

A Place for Rest from Toil

Every tree seems to have struck root for a certain purpose thirty to fifty years ago. What lovely carriage drives and promenades everywhere. Certainly Mr. Hartman has utilized every foot of ground to the best advantage. Descending a terrace one comes at intervals to three different springs that may be esteemed at least the greatest of all the attractions. These springs are singular and valuable gifts of nature. One of them is chalybeate; one is distinctly sulphur and one is freestone. The waters of all are delightfully cool and health-giving. It is a treat to drink from any of these springs. The lakes are fed from them. What a nice, grateful, healthful effect these fresh waters possess, kept constantly in motion by the work of a hydraulic ram. How the swarms of pretty gold and silver fish revel therein and come at a signal to take food from the hands of the proprietor. We have not touched on all the beauties and attractions of this rare spot, nor said anything of the variety of rare fruit trees and berries, all growing vigorously. What more desirable place can be found in Atlanta or in this whole country?

A hydraulic ram pumped the spring water to the top terrace, where the pressure was used to power a water fountain in one of the lakes. Hartman raised goldfish in the lakes and sold them throughout the country, providing a small stream of revenue from the park. The Japanese pavilion was thirty feet high and was built out into the lake so that visitors could sit in the shade on the waters. Because he never realized the profits from a beer garden, Hartman tried to sell Little Tyrol the entire time he owned it. He believed the spot to be perfect for an academy or a men's club. The large sewer line running through the property affected the value negatively as well. In 1909, the lot finally sold for development for $15,000.

Ponce de Leon Springs developed into a full-blown amusement park beginning in 1903, when the Ponce de Leon Amusement Company bought the springs and the surrounding forty-seven acres. The company officially renamed the springs Ponce de Leon Park, hoping the park would become nationally known for the latest outdoor amusements, not unlike Coney Island. The park was distinctly different after 1903; it was no longer primarily a recreational area surrounding some springs but, rather, a man-made theme park.

A sixty-foot oak platform led visitors from the trolleys on Ponce de Leon Avenue into the park. Upon entering, park patrons could visit the Casino, which was not a casino but a theatre. Some of the amusements were a merry-go-round, a laughing gallery, a cave of winds, a Japanese ping-pong parlor, a pony track and a miniature railroad. Across the street, the lake was

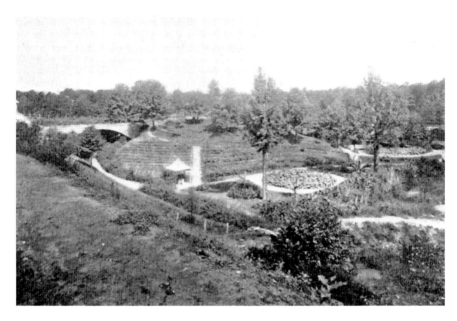

Little Tyrol park encompassed several acres of terraced gardens. It is seen here in 1895.

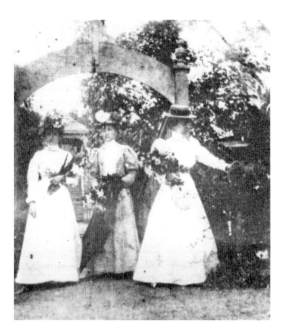

Three Victorian women gather flowers in Little Tyrol, which was located on the north side of Ponce, just east of Myrtle Street.

stocked with electric boats. There were two restaurants and plenty of snack pavilions that served popcorn and candy. The park's attractions were similar to the attractions at expositions or world's fairs that were immensely popular throughout the world in the nineteenth and early twentieth centuries. Atlanta had recently hosted the 1895 Cotton States and International Exposition at Piedmont Park; its Midway attractions were almost identical to Ponce de Leon Park's attractions, although on a larger scale. In 1906, a new company—the Ponce de Leon Park Association—invested $50,000 into updating the amusement park further. That same year, Democratic presidential candidate William Jennings Bryan, on a speaking tour around the country, spoke at Ponce de Leon Park in front of seven thousand people at the St. Nicholas Auditorium. The auditorium also was home to allegedly the largest skating rink in America at that time. Patrons claimed the roller rink was always cool in Atlanta's hot summers because it was on a hill and had high, vaulted ceilings.

Ponce de Leon Park was a convenient amusement park to Atlantans during a time when Atlanta, and all of America, was on the cusp of modern civilization and its many entertainment options. At the turn of the nineteenth century, the trolley was necessary for easy urban travel, and this park literally was created to accommodate streetcar riders. The late Victorian person was amused at simple diversions such as a roller rink or a penny arcade; he was not jaded by television and easy world travel. Theatres were more difficult to access in the era before the automobile, providing yet another reason for the people to throng to a park on the trolley line. A narrow window of time existed for Ponce de Leon Park's success. The park existed and thrived during a limited period when automobile use was not developed and when people hungered for carnival-like amusements. By the early 1920s, Ponce de Leon Park was dead. Atlantans had moved on to different amusements, and they could drive their cars to get to them. The Sears, Roebuck Company bought the park in 1926, demolished it and commenced building its massive department store and distribution center on the site. And the springs disappeared.

It would be remiss to fail to mention that Ponce de Leon Park was for whites only and publicly displayed signs reading the same. As inconceivable as that racism is to modern America's sensibilities, segregation or outright banning of African Americans was not uncommon at public facilities and, actually, was more the norm than non-segregated public facilities. Pre–Civil War attitudes still abounded in Atlanta; it had only been forty years since the war. Segregation continued until the civil rights movement, and as wrong

Ponce de Leon Avenue is shown in this 1907 postcard as a dirt road in the background. Ponce de Leon Park closed during the winter, which it appears to be here, as the trees are barren of leaves and the park is deserted.

as segregation or banning of African Americans was, it would be unfair to single out Ponce de Leon Park as a whites-only park without also mentioning it in the context of the turn-of-the-nineteenth-century mind and practice, when racism was common. Other Atlanta parks were also "whites only" at that time. The infamous Atlanta Race Riot of 1906—which occurred during the height of Ponce de Leon Park's success—fed on the misconceptions, fear and racism that were common ideas in the early 1900s.

Old "Poncey," the baseball stadium on Ponce de Leon Avenue, was built on the site of the four-acre lake across the street from the Ponce de Leon Park and springs location. Its real name was the Ponce de Leon Ballpark. From 1907 until 1965, the Atlanta Crackers minor-league baseball team played in the valley where Midtown Place Shopping Center is now located. There were actually two stadiums: a wooden one built in 1907 and a steel and concrete one built in 1923. The Georgia Railway and Electric Company, predecessor to Georgia Power, drained the lake and built the first stadium in 1907 for $60,000. The company sold the stadium and team to Rell Jackson Spiller in 1922, and he was the builder of the 1923 stadium after a fire burned the wooden stands to the ground. R.J. Spiller renamed the park Spiller Field, but it never caught on with fans of Poncey; in 1932, the ballpark was renamed Ponce de Leon Ballpark. The Coca-Cola Company, under the leadership of Robert Woodruff, bought the Crackers and their

Someone wrote "A place for rest from toil" on this postcard and mailed it in 1908—the height of Ponce de Leon Park's popularity.

field from Spiller and bankrolled the team during the Depression, as Atlanta needed a boost in morale during the tough economic times. The City of Atlanta briefly owned the team as well. Otis Earl Mann bought the Atlanta Crackers in 1949, and he held onto the land until 1965, when he sold it for $1,750,000. The stadium was demolished shortly thereafter, and the Atlanta Braves rolled into town and claimed the city's baseball fans. Ponce de Leon Ballpark was also used for mass meetings, religious revivals, rodeos, concerts and football games.

The Crackers did well during their run as Atlanta's baseball team and won more pennants than any other team in their league. Baseball greats such as Babe Ruth, Jackie Robinson, Mickey Mantle and Lou Gehrig played at Poncey. Two legendary stories always accompany the history of the ballpark, and one of the stories involves a tree in the field. There was no fence in center field because the embankment that led to the railroad tracks was included in the field and formed the outer boundary. A magnolia tree—462 feet from home plate—was considered "in play," and players who hit a ball into the tree usually had hit a home run. Babe Ruth and Eddie Mathews were the only players to ever hit a ball into this tree, which still stands behind the shopping center today. The Ponce de Leon Ballpark contained the only tree in its field in professional baseball and holds that distinction today. The other story of legendary lore from Poncey involves one of the trains that traveled on the embankment adjoining the field. In 1954, Atlanta Cracker Bob Montag hit a baseball into a passing coal car,

and the ball traveled to Nashville, Tennessee, and back to Atlanta, making it the longest home run hit in history. The train conductor returned the coal dust–blackened ball, bringing it right into the stadium offices and handing it to Bob Montag for an autograph.

In 1949, during a three-game exhibition series between the Crackers and the Brooklyn Dodgers, the ballpark hosted the first integrated professional game in the history of Atlanta when Jackie Robinson took the bat. Previously, there had been a separate African American league, in which the Black Crackers represented Atlanta. Like most everywhere else at the time, the baseball stadium was segregated, with the worst seats specified for the African Americans. The Black Crackers could play at Ponce only when the white Crackers were out of town at away games. Players for the Black Crackers could not shower or change clothes inside the white Crackers' facilities. Their uniforms were often hand-me-downs from the white Crackers. Interestingly, both whites and blacks often showed up for the Black Crackers' games, and the segregation was suspended for those days, allowing both races to mix in the stands. The African American league disbanded soon after the 1949 game—a beginning step in racial equality.

R.J. Spiller, who owned the Atlanta Crackers for about ten years, moved to Lithia Springs, Georgia, after he sold the team. Spiller, who was never seen in his life without a hat, built a golf course and began bottling water at

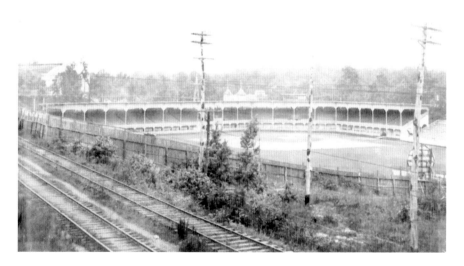

Ponce de Leon Ballpark is shown here about 1910. In the background is Ponce de Leon Park with the St. Nicholas Auditorium on the left.

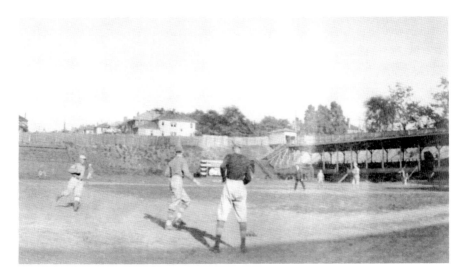

The Atlanta Crackers are seen playing here at the Ponce de Leon Ballpark in 1920.

Lithia Springs. He called the water bottling company the Fountain of Youth, probably paying homage to Ponce de Leon Avenue and the ballpark. Spiller's son-in-law was Crackers' pitcher Johnnie Suggs, and Suggs's daughter is golf legend Louise Suggs (b. 1923). After his baseball-playing days were over, Johnnie Suggs managed the Lithia Springs Golf Course and went on to build other courses. He taught his daughter Louise to play at the Lithia Springs course when she was ten years old. Spiller continued operating the bottling company until his death in 1946.

As discussed in chapter two, Freedom Park is a linear park, which is the result of the Georgia Department of Transportation's aborted plan to build a highway through Atlanta. It is the largest urban park in America that was built in the twentieth century. Part of the park is adjacent to Ponce de Leon Avenue, between Barnett Street and Bonaventure Avenue on the south side of the avenue. There at the junction of Ponce and the park is a large piece of outdoor sculpture marking an area of the park called the John Lewis Plaza. The plaza and the sculpture erected with it, named *The Bridge*, commemorate U.S. congressman John Lewis's part in the civil rights movement, his help in the Road Fight that saved many of Atlanta's historic neighborhoods from the proposed highway and his lifetime commitment to human rights.

Representative Lewis was allowed to choose the artist to commission for the sculpture, and he chose Thornton Dial, known for his outsider or untrained art. Born in 1928 in rural Alabama, this illiterate African

American folk artist has received national fame since he was discovered in the 1980s. Dial's art, which includes both paintings and sculptures, is often a mix of found objects and paint, and he speaks of social issues through his work. His pieces have incorporated animal bones, plastic toys, carpet and twisted metal. *The Bridge* is highly representative of his work, although the found objects incorporated in it are durable to stand the test of time. It is forty-two feet by eleven and a half feet and made of metal.

In 2005, at the official opening of the John Lewis Plaza and unveiling of the sculpture, Representative Lewis said, "I am humbled and honored by this wonderful work of art, *The Bridge*, being placed in this historic section of Atlanta. Over the years I have only tried to play a small role in making life better for all people. It is my hope and prayer that this work will inspire others to build bridges of understanding."

Another green space that was affected by the threat of the highway through Atlanta is the Olmsted Linear Park. This string of connected parks and the two streets around them (today, Ponce de Leon Avenue and South Ponce de Leon Avenue) were originally the north and south sides of Ponce de Leon Parkway, and their creation is the way that Ponce de Leon Avenue was extended eastward and became connected to Decatur, Georgia. Around 1890, Atlanta entrepreneur, neighborhood developer and streetcar mogul Joel Hurt bought 1,492 acres of land, which later became the Druid Hills neighborhood. He sought out the help of Frederick Law Olmsted Sr. in laying out the subdivision. Olmsted was the country's premier landscape designer in the nineteenth century, designing such outdoor wonders as Central Park in New York City; the Biltmore Estate grounds in Ashville, North Carolina; Riverside in Chicago, Illinois; and the Capitol grounds in Washington, D.C. Olmsted submitted a proposed plan to Hurt in 1893, and fifteen years later, with the help of Olmsted's son and stepson, the parkway came into fruition. (Olmsted had died before the project was completed, but his sons continued his work.) The "parkway" concept was central to many of Olmsted's residential visions. It provided a link, through a picturesque road or trolley line, from urban development to residential development, thus allowing the traveler to experience nature and its calming effects to and from the city and home.

The six park areas composing the Olmsted Linear Park on Ponce de Leon Avenue from west to east are Springdale, Virgilee, Oak Grove, Shadyside, Dellwood and Deepdene. The entire park is owned by the City of Atlanta, except for a portion in Dellwood and all of Deepdene, which are owned by Fernbank, a science museum and science center adjacent to Ponce. Over

time, the parks lost some of their Olmsted characteristics and experienced the wear and tear of urban use and lack of maintenance. In 1997, the Olmsted Linear Park Alliance was created to stabilize the park and to re-create the original Olmsted look of the park. The group has raised $9.5 million and has made such improvements to the hardscape and landscape of the parks so as to impart the original appearance and feel of the plan begun by Olmsted and completed by his sons in 1905.

In the early twentieth century, trolleys ran through the Olmsted Park, connecting Druid Hills to the city. The trolley tracks were set level with the ground, and grass grew around them to provide a more natural look for the riders as they traveled the parkway. The park has been part of Atlanta's drive eastward from the city since its inception and has provided a recreational and picnicking space for the city as well. Shadyside was even used as a tent city during the Road Fight against the Georgia Department of Transportation in the 1980s. While the linear park provides drivers of Ponce a scenic blur through their automobile windows, the true value of the park can best be appreciated on foot. The alliance has had the power lines buried, and the historically accurate trees, shrubs and flowers work together to create a pastoral and peaceful environment in the city. Olmsted's true vision can be seen in the park today.

Looking east toward Decatur, Ponce de Leon Avenue is being constructed on the left, and South Ponce de Leon Avenue is being constructed on the right. John C. Olmsted took this photograph on July 25, 1902. *Courtesy of the National Park Service, Frederick Law Olmsted National Historic Site.*

BREAKING BREAD AND CUTTING A RUG

On April 1, 1928, the Pig'n Whistle restaurant opened on Ponce de Leon Avenue on the southwest corner of Argonne Avenue and Ponce, where the Krispy Kreme Doughnut restaurant is located today. The restaurant replaced its building in 1939 with a new Old English–style structure designed by architect Robert B. Logan of the Edwards and Sayward firm. The Pig'n Whistle was a departure from the norm for the firm, as Edwards and Sayward primarily designed educational facilities such as Roosevelt High School in Atlanta's Grant Park, Columbia Seminary in Decatur and the University of Florida in Gainesville, Florida. By 1939, the restaurant claimed to have served ten million sandwiches, and by 1947, the restaurant was serving three thousand customers a day.

The name "Pig and Whistle" is a common one for English pubs, and there are many establishments with that moniker worldwide, including the chain of barbecue restaurants that started in Atlanta. It is believed that "pig" could be derived from the word "piggen," which was a vessel, and "whistle" could be from "wassail," meaning a cider drink or an old English term for "good health." Still others believe the pig and whistle sign was simply an iconic notice to illiterate travelers in old England that an establishment served food and drink.

The owner of the Pig'n Whistle on Ponce was Harold Terris Hagan (1896–1953), an Atlanta native who grew up in the area. His father, Lee Hagan, was one of the founders of the Red Rock Company, a manufacturer of ginger ale, and Harold worked at the company after he graduated from Washington and Lee University. Harold Hagan also owned a restaurant named Peacock Alley at Spring and West Peachtree Streets, which was a drive-in food establishment. An advertising mailer (dating from the building of the new facilities in 1939) from the Pig'n Whistle on Ponce describes the experience of eating at the restaurant:

> *The New delightful and cool main Dining Room. Here fine steaks, barbequed chicken and many tasty dishes are served. It's just the spot for delightful informal entertainment. Make a trip to the spotless kitchen a part of your visit. Let our chef proudly show you the modern pit where golden-brown barbecue is always being prepared for flavor perfection. After the bridge game or the movies, the new Men's Grill is just the spot to relax and enjoy your favorite beverages. Hundreds of businessmen meet here for lunch every day. The beautiful counter room is open 24 hours a day. Just the spot for a late*

snack or early breakfast. It's just the place for the entire family to share a delightful evening and where trained chefs have done all the necessary work and planning. You will see just how much more ENJOYABLE and LESS EXPENSIVE it is to enjoy delicious, well-prepared food when you visit "The New Pig'n Whistle." Parking accommodations for over two hundred cars.

Legendary blues guitarist Blind Willie McTell was known to play his twelve-string guitar in the parking lot of the Pig'n Whistle on Ponce for tips. McTell was born in Thompson, Georgia, around 1900. His birth name was William Samuel McTier, but in the illiterate, backwoods area in which he was born, the name became slurred over time, and McTell became Willie's last name. He was born blind in one eye and became blind in the other eye during childhood, spending most of his childhood in Statesboro, Georgia. When McTell's mother died in 1920, leaving her blind son virtually alone in the world, he began playing the guitar in public to support himself. It is believed his mother taught him to play the guitar. An unknown benefactor paid for McTell to attend the Georgia School for the Blind in Macon, Georgia, where he learned Braille and continued with his music education. Blind Willie McTell spent the rest of his life as a traveling blues player and

In 1940, the Pig'n Whistle was the best barbecue restaurant in town. It was located on Ponce de Leon Avenue where the Krispy Kreme Doughnuts is now located.

Blind Willie McTell is seen here recording his songs in an Atlanta hotel room for John Lomax of the Library of Congress in 1940. *Courtesy of the Library of Congress.*

occasionally recorded his songs under several different aliases, but he never achieved any real measure of success during his lifetime. It was common practice in those days to get around contractual obligations with recording studios for an artist to simply change the name he used in the recording. One of McTell's aliases was "Pig'n Whistle Red." He also played for tips at the building that is now the Local nightclub on Ponce. In 1928, Blind Willie recorded his song "Statesboro Blues," and in 1971, the Allman Brothers band re-recorded it with great success. Bob Dylan wrote a song in 1993 called "Blind Willie McTell." A nearby blues bar in the neighborhood of Virginia-Highland—Blind Willie's—is named for McTell. He died of a stroke in Central State Hospital in Milledgeville, Georgia, in 1959—blind, diabetic, alcoholic and poor. Blind Willie McTell was inducted into the Blues Foundation's Hall of Fame in 1981 and into the Georgia Music Hall of Fame in 1990.

Mary Mac's Tea Room was named for its founder, Mary McKinsey, who bought the restaurant from a friend in 1951. The friend had started her restaurant, Mrs. Fuller's Tea Room, in the late 1940s. In those days, the name "tearoom" seemed more respectable for a woman to own than a restaurant business. The restaurant is located on the northeast corner of Myrtle Street and Ponce de Leon Avenue where Little Tyrol was located at the turn of the nineteenth century. Mary McKinsey sold her restaurant to Margaret Lupo in 1962, and Lupo sold it in 1994 to John Ferrell. McKinsey, and both the owners after her, took time to work with the previous owner and learn the recipes so that even though the ownership changed over time, the food and the atmosphere remain the same even today. The retail strip where the restaurant is located held a number of different businesses— the Ponce de Leon Liquor Store, Central Electric, the White Dot and the Fulton Pharmacy—and Margaret Lupo bought the stores and connected them to enlarge the restaurant. The White Dot then moved across the street.

A Place for Rest from Toil

Mary Mac's is known for its down-home southern cooking. Patrons write their orders themselves and hand them to the waitresses. The restaurant is frequented by movie stars, politicians and just regular folks, and it was never segregated like so many other Atlanta establishments were during the 1950s.

On the southwest corner of Ponce and Argonne Avenue where the Pig'n Whistle was located is now the Krispy Kreme Doughnut store and restaurant. Krispy Kreme came to Atlanta from Winston-Salem, North Carolina, around 1938. At first, it was only a wholesale store at 451 Ponce de Leon Avenue (between Charles Allen and Monroe Drives on the south side of Ponce). The restaurant moved to its current location in the early 1960s. Even though the restaurant is franchised and grocery stores sell the product today, Atlantans and tourists still travel to the Ponce de Leon Avenue Krispy Kreme location for sentimental reasons.

The most iconic restaurant on Ponce de Leon Avenue is the Majestic Diner, on the southwest corner of Cleburne Terrace and Ponce. Since 1939, the restaurant has been serving up diner food twenty-four hours a day in its nostalgic Art Deco building, which is part of the Briarcliff Plaza Shopping Center. Two facts are emblazoned on the exterior in neon lights: the diner has been open since 1929, and it serves "food that pleases." The diner stays as packed today as it always has with regulars from the neighborhood, tourists, college students and the occasional ne'er-do-well.

On October 5, 1929, days before the great stock market crash, co-founders Charles Kliros and George Kotsoyianis opened their first Majestic Diner restaurant on Peachtree Street at Tenth Street. The Greek immigrant co-owners had finally accomplished their dreams of owning a little restaurant in a big, flashy American city. They signed the lease for the Ponce location in 1938 and opened for business in Atlanta's first true shopping center—the Briarcliff Plaza—the following year. They opened two more Majestic Diners over the next decade, but only the one on Ponce survived. In 1968, they sold the restaurant to Kleomenis "KK" Kliossis, Nick Bitzis and George "Junior" Papadopoulis. The first two men listed were cousins, and the last man was a nephew of original co-founder George Kotsoyianis. KK was the chief cook, baker and check signer, and he did not use a recipe book or a timer to prepare the breads, pies, meats, vegetables and breakfast foods he made eleven hours a day. Bitzis worked the late-night shifts. His booming voice and, occasionally, the baseball bat he kept behind the counter for rowdy drunks made him a well-loved father figure to the workers and customers. Today, the diner is owned by Tasso Costarides. And to remind the customer of the diner's Ponce location and Greek heritage,

any time—day or night—he can order a Ponce de la Orange milkshake or a Baklava sundae to follow his Ponce Dog or Greek salad.

A few restaurants have come and gone on Ponce but are still remembered fondly by the city. The Happy Dolphin—a Greek restaurant with belly dancers—was located at the northwest corner of Ponce and Lakeview Drive. Today, it is known as the restaurant called Eats, owned by Robert Hatcher and Charles Kerns, but during the days of the Atlanta Crackers, it was a cafeteria with windows that looked out toward the field. A burrito restaurant, Tortillas, was a Ponce de Leon institution for nineteen years and was also owned by Hatcher and Kerns.

Ponce de Leon Avenue has had a number of adult clubs over the years, with the most notable one being the Clermont Lounge, located in the basement of the Clermont Motor Hotel. It is reputed to be the oldest such club in the city, opening in 1965 and in continual operation since that time. The Clermont Lounge is more than a strip joint; it is a magnet to people from many different stations in life—from celebrities to grungy locals—and its allure is that it is comically raunchy. The strippers in the club are known more for their personalities than perfect looks. One such dancer, "Blondie," is especially well known for her dancing, as well as for her poetry and advocacy for gay rights and recycling. She has been entertaining at the Clermont for over three decades. Prior to the club's opening in 1965, there were a number of clubs in the basement of the Clermont Hotel. Some of these were the Anchorage, the Gypsy Club, the Atlanta Playboy Club and the Jungle Club. Other clubs, such as the Whisk A Go-Go and the Copa, were in business on Ponce in the mid-twentieth century; those two clubs were located just east of the Georgian Terrace Hotel.

Countless dinner, dancing, music and gay nightclubs have come and gone on Ponce de Leon Avenue, including the White Dot, Ray's Blue Lantern, the Phoenix, the Starlite Lounge, Buddie's, the Electric Ballroom, the Joy Lounge and Mrs. P's. Others, such as the Atlanta Eagle, the Book House Pub, Model T's, the Local, Dugan's, El Bar, Friends on Ponce, MJQ Concourse and the Drunken Unicorn, are part of Atlanta's current nightlife.

The Atlanta Eagle, a gay nightclub, has been in business for over twenty-five years; its building history is discussed in the previous chapter. In 2009, the now-defunct Red Dog Unit of the Atlanta Police Department allegedly improperly searched and detained the patrons and employees of the club, which resulted in a civil rights lawsuit against the city and thirty-five individual police officers. The case settlement included a monetary compensation and reforms for the police department.

Showbiz and Social Clubs

The lot on the northwest corner of Ponce de Leon Avenue and Peachtree Street—Hannibal Kimball's old home lot—became home to the Fox Theatre in the late 1920s. In 1922, the Atlanta Shriners fraternal organization, a subgroup of the Masons, bought the lot with the intention of building a headquarters or Yaarab Mosque there. The group of about four thousand Atlanta-area men paid $225,000 for the land. Henry Heinz, who was married to Asa Candler's daughter and was later murdered at his house on Ponce, was the first Shriner to suggest that the headquarters could also serve as a theatre and provide an income to the mosque.

Most noticeable about the Fox's appearance is its decidedly Middle Eastern theme. Its striped brickwork and onion domes are easily seen on Ponce de Leon Avenue and Peachtree Street, and the interior reflects the motif with Egyptian and Arabian symbols. Three factors affected the choice in this décor: the Masons had Middle Eastern origins, the Shriners had recently visited the Middle East in 1918 and the tomb of King Tutankhamen or "King Tut" had just been discovered in 1922. Many of the Masonic temples around the country have a Middle Eastern look.

After holding a contest among architects, the Shriners hired the architectural firm of Marye, Alger and Vinour to design their mosque, whose principal architects were Philip Thornton Marye, Barrett Alger and Ollivier Joseph Marie Vinour (1889–1951). Over thirty draftsmen took months to complete the drawings and models for the theatre, and in the end, the project went severely over budget at $2.5 million in building costs. Marye was famous for his design of the Atlanta Terminal Station, but it was architect Vinour who was the true creator of the Fox Theatre design. As a teenager, he had been educated at the École des Beaux-Arts in Paris, and French-born Ollivier Vinour was responsible for many other designs in the South, including the BellSouth Building in Winston-Salem, North Carolina. Vinour was known to become so completely consumed by his work that when he was involved in a project, he sometimes could not remember what he had eaten for dinner that day. He had a good sense of humor, and when he moved to the United States in 1919, Vinour was fascinated with cowboys and sent a photograph of himself dressed as one to his family in France. After working at the firm of Marye, Alger and Vinour for about five years, Vinour moved on to other projects, such as judging architectural renderings at Georgia Tech and designing buildings at army bases in Georgia and Florida. In 1945, Vinour joined an architectural firm in Dallas, Texas, and

six years later, he was killed instantly in a head-on automobile collision with an intoxicated driver.

The Fox's early years took place during America's golden age of the movie palace, when patrons were treated like royalty and the facilities were bedecked with velvet and gild. The lavish theatre was as much a part of the experience as the entertainment. Film mogul and producer William Fox (whose real name was Vilmos Fried in his native Hungary) agreed to lease the theatre from the Shriners for twenty-one years. The Fox Broadcasting Company and 20th Century Fox Studios still bear his Americanized name today. Before Fox went bankrupt in 1932, he influenced the Fox Theatre for all time by convincing the Shriners that the front door and marquee should face Peachtree Street and not Ponce de Leon Avenue, as originally planned. His wife, Eve Fox, decorated the theatre's public spaces. The Fox Theatre opened on Christmas Day 1929, just two months after the famous stock market crash. In the auditorium during the opening show, forty-five hundred people sang in unison the songs "Let Me Call You Sweetheart" and "Singin' in the Rain."

Financially, the theatre struggled for many years, with periods of success interspersed with various owners and low profits. The 1940s were profitable years for the Fox. The theatre's Möller organ, nicknamed "Mighty Mo," was restored in 1963 by Joe G. Patton, the theatre's technical director. He rewired the 3,622-pipe organ with seven miles of new wire. He has lived in an apartment inside the Fox Theatre since 1981 and continues to do so today. Mr. Patton is called the "Phantom of the Fox"; he is known for quietly slipping around the theatre and guarding its safety. The theatre was slated for demolition in 1975, but Patton and many of the city's people and businesses got behind a "Save the Fox" campaign, which did work: the Fox was saved and is thriving today.

The building itself is a wonder. It had air conditioning five years before the White House was air conditioned, and the system itself has an incredible ability to cool the huge auditorium in ten minutes. The auditorium is atmospheric, meaning that the seated visitor feels that he is outdoors because of a changing overhead appearance of a sky. The interior of the auditorium is made to look like an Arabian courtyard, and the balcony is canopied like a tent in the desert. Ninety-six stars sparkle overhead in the auditorium; one-third of them have heat sensors, which make them twinkle. For many years, it was rumored that one of the twinkling stars was actually a Coca-Cola bottle, and in 2010, when two of the staff braved the Fox's attic, they did find a piece of a Coca-Cola bottle embedded in the ceiling with the star crystals. Projected clouds flit across the sky in a one-and-a-half-hour sequence. The

auditorium seats almost five thousand people. Fifty-five seats in the balcony came from the demolished Loew's Grand Theatre. Loew's was a downtown Atlanta theatre in operation from 1893 to 1978 and was where *Gone with the Wind* first premiered. When the balcony at the Fox is at full capacity, it actually moves three inches to absorb the weight.

Since the "Save the Fox" campaign in the 1970s, the Fox has spent over $30 million on restoration projects and keeps an in-house staff of preservation specialists continually working on the theatre. It is a fully functional and popular performance venue in Atlanta. The theatre is on the National Register of Historic Places and is a National Historic Landmark.

As discussed in chapter two, the New York Metropolitan Opera began visiting Atlanta in 1910, when Enrico Caruso (1873–1921) was a member of the group. Caruso is considered to be the world's greatest operatic tenor. In the early days, the Met stayed at the Georgian Terrace on Ponce but performed at the Auditorium-Armory. From 1947 until 1967, the Met visited Atlanta every spring for one week, known as the "Gala Week," and

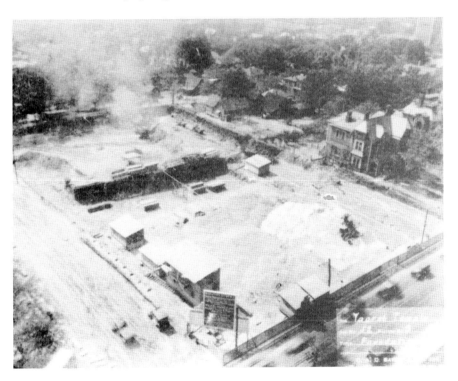

The Fox Theatre's foundation was just starting to be excavated and laid in this photograph, which was taken from the roof of the Ponce de Leon Apartments in 1929.

This photograph was taken from the roof of the Ponce de Leon Apartments in 2011.

performed at the Fox Theatre. The week of the Met's performances was a social event in the city, and grand parties were given at the Georgian Terrace and other hotels and clubs during that week.

On the north side of Ponce de Leon Avenue, between Durant Place and Charles Allen Drive, is a large lot that was divided into smaller residential lots early in the twentieth century. This large lot has been used and reused by Atlantans. The Standard Club—a Jewish social club that started in 1866— bought a lot in this area and built a clubhouse in 1929. The Standard Club facility was designed by Rudolph Sartorius Adler (1889–1945) of Hentz, Adler and Shutze, and it contained a ballroom, dining room, card rooms and a billiards room. At that time, that architectural firm was building some of the finest private homes in the city, many of them along West Paces Ferry Road in the Buckhead portion of Atlanta. A pool and a tennis court were on the grounds of the Standard Club. After World War II, the club left Ponce and eventually ended up where it is today in north Fulton County. In the 1920s, some of the houses were used as the Shady Rest Tourist Hotel (as discussed in chapter two), but in 1964, the Shriners built their second

Famed tenor Enrico Caruso (left) is pictured here with Henry M. Atkinson outside the Georgian Terrace Hotel about 1915.

temple on Ponce on this land. Today it is called the Yaarab Shrine Center. In addition to the Shriners' fraternal and philanthropic activities, the center's auditorium is used by the Atlanta Rollergirls roller derby team.

On the southwest corner of Ponce and North Highland Avenue in the Briarcliff Plaza Shopping Center is the Plaza Theatre. The theatre's original Art Deco marquee of a blue fan dominates the façade of the old shopping center and captures the attention of passersby. Upon entering the theatre, it is almost as if time has stopped; it is 1939 again. Few real changes to the

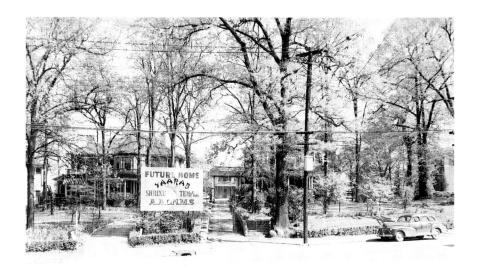

The Shriners built their second temple on Ponce de Leon Avenue in 1964, and it is still in use today. *Courtesy of the Special Collections Department, Georgia State University.*

theatre have marred its appearance. Inside the one-thousand-seat first-floor auditorium, the original Art Deco wall sconces still glow on the walls. Golden velvet curtains lend a regal air to the cinema. While it is no grand movie palace among the ilk of the Fox Theatre, it is a neighborhood theatre that was built during the time when movies were even more important than they are today, for there were few other entertainment distractions. The theatre has a quiet atmosphere of a place built to be a small but chic venue for Atlanta's historic intown neighborhoods, and it is still exactly that—a stylish theatre. Upstairs, the second auditorium is a walled-in balcony, utilitarian in appearance. However, the adjacent projection room is almost unchanged from the early years; it is where the magic of movies shown on real film happens. The Plaza Theatre still uses real film, almost unheard of in today's technologically savvy world. Among true cinema fans, movies shown on actual film versus the modern-day DVDs are supreme and paramount for true enjoyment. Before VHS and DVD, a projectionist using film was a jack-of-all-trades—an artist, an engineer, an electrician and a mechanic.

The theatre's history echoes that of Ponce de Leon Avenue's history. It was built as part of the Briarcliff Plaza Shopping Center (see chapter four) in 1939. It is the oldest continually running movie theatre in Atlanta and remains open today. The first film shown at the theatre was *The Women*, starring Joan Crawford. When Ponce de Leon Avenue was suffering most

and at its lowest point in the 1970s, the theatre remained open, but it showed X-rated movies. As the street and surrounding neighborhoods began to start revitalizing in the 1980s, the shopping center was renovated and George LaFont bought the theatre, turning the balcony into a separate auditorium. In time, the theatre began showing independent, classic and foreign films, and it continues to do so today. In 2006, Jonathan and Gail Rej bought the theatre, and by 2010, it became a nonprofit organization, growing and becoming an important part of the community. It is here where Atlantans meet every Friday night for a midnight showing of *The Rocky Horror Picture Show*, with simultaneous live performances and audience participation, and where consistently interesting films are shown. In time, the Plaza Theatre plans on doing some renovations, and it needs a bigger following than the large cult following it already has obtained. In the meantime, it still feels like 1939 in the Plaza, and there is still an original "baby-crying room" hidden upstairs where women used to hold their infants and watch movies through glass windows. And the sound of running film at the Plaza continues on Ponce as it has done for over seventy years.

Just east of the Briarcliff Plaza Shopping Center is the Atlanta Boy Choir facility on South Ponce de Leon Avenue. After beginning in the Atlanta

Inside the Plaza Theatre, the projection room remains similar to its original 1939 condition. Because the theatre uses real film, the projection room resembles a workshop.

Public Schools in the 1940s and continuing in a local church, the Atlanta Boy Choir, Inc. was founded and has charmed the world since 1959. Two directors, Fletcher Wolfe and David White, have led the choir, with Wolfe being director for all of the years since the founding except for nine when White was director. The choir has traveled the world, including performances at the White House in Washington, D.C.; the Notre Dame Cathedral in Paris, France; and St. Peter's Basilica in Rome, Italy. The Boy Choir won a Grammy Award for its performance with the Atlanta Symphony Orchestra of Benjamin Britten's *War Requiem*. The choir has been featured on television and radio and has released several albums. It has entertained leaders of countries as well as Atlanta citizens on Ponce.

EPILOGUE

Its limpid flow, unchecked by the lapse of time, is as pure and bright, as full of life and light, as though born of yesterday. Unclouded by the sad memories of former years, its sweet waters dance in the sheen of the same silver moon which more than a century ago invited the Indian lover and his dusky mate to this quiet retreat.
—Charles Colcock Jones Jr.

In 1862, lawyer and Georgia historian Charles C. Jones Jr. wrote those words in a letter to his mother. He was attempting to describe a spring he was camped around with his fellow Confederate soldiers, and his description of this spring in Calhoun, Georgia, articulates the sense of history that surrounds the old Ponce de Leon Springs in Atlanta. Contrary to the Calhoun spring, the springs for which Ponce de Leon Avenue were named have been checked by the lapse of time; they have been capped, funneled, pumped and still seek to escape the confines of their grounds even today. Although the casual observer may not know they ever existed alongside the road, the springs are the essence of Ponce de Leon Avenue. Their ebb and flow have reflected the pulse of Atlanta.

Today, there is no flowing spring at which to place a cup and catch the water that once sprang freely from the ground, forming streaming creeks throughout the park. In most places on the earth, groundwater flows underneath the soil and can be reached by digging wells. In like manner, the historic Ponce de Leon Springs are still flowing under the ground, but their exodus from the earth was capped when the Sears, Roebuck Company built

its massive building on the park grounds. At that point in time—1926—the Ponce de Leon Springs vanished from sight.

Many Atlanta historians believe the springs still exist and are under the Sears Building, but that is not exactly correct. The springs are an integral part of Atlanta's history, and they deserve to have their exact location pinpointed if at all possible. Most of the events described in the preceding chapters occurred where they did because at one time, a long time ago, two springs flowed out from the ground and drew people to them. The site of the Ponce de Leon amusement park is definitely under the Sears Building, but it appears under close study that the historic site of the actual springs was in a location slightly east of where the brick building was built in 1926.

A description of the landscape should be provided for the Ponce de Leon Springs site in the years between the springs' discovery in 1868 and their disappearance in 1926. As long as history has been recorded, there has been a steep ridge or embankment running north and south and crossing Ponce, and upon this ridge, the Beltline railroad was built. The springs site—just west of the railroad embankment and on the south side of Ponce—contained a small hill and a larger hill where the St. Nicholas Auditorium was later built. The entire spring site was below the level of Ponce de Leon Avenue. For clarification, from henceforth, the foregoing will be referred to as the "railroad embankment," the "small hill" and the "St. Nicholas Auditorium hill."

First accounts of the spring indicate that the water sprang forth from the bottom of the railroad embankment. An anonymous firsthand account of the Ponce de Leon Springs was printed in the *Atlanta Constitution* on May 14, 1872:

> *Swiftly we turned a sharp corner of Virginny rail and down we ran into a wild, weird-looking spot shut in apparently from all surroundings. To the left rose a high embankment crowned with railroad, "Air-Line," we stop at the base. To the right rises a small hill, at its foot a substantially large covered platform has been erected for dancing. The hill is terraced in steps, winding around to its summit. In front, a higher hill; steps well secured, of strong wood, have been placed up its sides…The Springs are at the base of a railroad embankment, and between that and the main hill. They gush clear and cool out of a large rock.*

An etching, shown here, appeared in a December 1879 *Harper's Magazine* article in which the writer, Ernest Ingersoll, visited Atlanta and reported

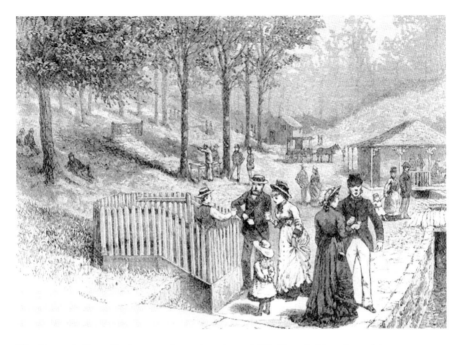

The Ponce de Leon Springs are shown here in an 1879 *Harper's Magazine* article.

his findings. On the left side is the railroad embankment, and in the right background is one of the hills. The springs, in the foreground, are shown to be in an enclosed area at the base of the embankment; a boy is collecting water in cups and handing them out to people.

The 1911 Sanborn Fire Insurance map shown on page 118 should be compared to the 1928 U.S. Geological Survey Topographical map, also on page 118. Both maps indicate the Beltline railroad tracks running north and south. Although it is difficult to read, in the 1911 map, under close magnification, the springhouse is the octagonal structure on the far right side of the map marked "Spring Ho." To the east and behind the springhouse, the words marked are "Bottom of Embankment." The 1911 Sanborn map shows the springs flowing from the bottom of the railroad embankment and directly into the creek, which is marked "Small Creek," running parallel to Ponce.

On the 1928 topographical map, the lines drawn close together indicate a deep grade, and thus, a hill would be at the top of the grade where there are no closely drawn lines. If the two maps are compared, the area at the bottom of the railroad embankment where the steep grade is drawn in the 1928 map is close to the historical spot where the Ponce de Leon Springs

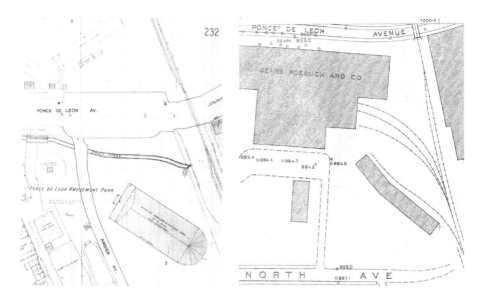

Above, left: This 1911 Sanborn Fire Insurance map shows the location of the springs at Ponce de Leon Park to be at the far right (east) and flowing into a small creek.

Above, right: The 1928 U.S. Geological Survey Topographical map shown here indicates the Sears, Roebuck and Company structures on the old Ponce de Leon Park site.

actually were, and that spot is not under the building. The small creek would have run where the Sears Building was built later, but the springs were at the bottom of the embankment.

Over the years since the Sears Building was constructed, the building has received additions, increasing the size from 750,000 square feet to over 2 million square feet, and the landscape has been manipulated. A truck driveway was built between the railroad embankment and the building, obscuring the original landscape. In spite of the human interference, the site of the historic place where the springs burst forth from the bottom of the embankment can be determined to an approximate vicinity: the springs were at the bottom of the railroad embankment, between the building and the embankment. In the 2011 photograph on page 119, the springs would have been close to the area underneath the crosswalk from the Sears Building to the railroad loading docks.

A year after the Sears Building was constructed in 1926, an article entitled "Sears, Roebuck to Revive Old Ponce de Leon Spring" appeared in the *Constitution* on July 24, 1927. This article stated that when the building was constructed, "the water flowage from the spring was temporarily disposed

of by tapping it into a sewer." The article further states that Sears had hired a company to drill an artesian well into the underground spring water. This well would supply the building with all water except drinking and boiler water, saving the company about two-thirds of its water costs. The plan was for the well to use hollow tile piping that would allow water seepage and spring flow to be obtained from 750 feet under the ground. Today, there is a nonworking pump of some sort on the bottom floor of the building that the current owners believe tapped into the springs. If so, this most likely would be the remnants of the artesian well.

At some point, the artesian well and pumps were closed, and the spring water had to go somewhere. According to the 1927 article referenced above, the artesian well's flow was expected to be one hundred gallons of water per minute, and historically, the springs were strong enough to supply a small creek. If the springs' flow did not weaken over time, there is quite a bit of water flow underground for disposal. In a March 7, 1974 *Atlanta Journal* article, John Crawford, construction manager and building consultant for Sears, stated that the springs had been capped and funneled into the main sewer line under the Sears Building and sent to the Chattahoochee River. This continues to be the fate of the legendary Ponce de Leon Springs to this

Taken from Ponce de Leon Avenue and looking southward, this 2011 photograph shows the approximate area where the springs were once located.

day—they probably still flow underground and into a large sewer line that runs behind the building.

The Ponce de Leon Springs not only caused the avenue to be built, but they reflect the state of the avenue as well. When the springs were in the wild, undiscovered part of Atlanta's primordial forest, so was the rest of Ponce de Leon Avenue. As civilization found the springs, so did civilization find and form the avenue. At the Ponce de Leon Springs' peak of popularity in the early twentieth century, the avenue was filled with mansions and trolleys, and the new Ponce de Leon Ballpark drew thousands to the avenue. When industry and commercialization deleted the springs' existence in 1926, the avenue became a place of business, too. Eventually, change in America's retail methods and continued suburbanization of the city caused the Sears store on top of the spring waters to close its doors, and the avenue, likewise, became a place in severe decline. During the years of the late twentieth century, the site of the springs and the avenue were both empty of real life and filled with urban debris.

Today, a transformation is occurring at the site of the old springs and on the avenue in three ways. First, the Atlanta Beltline development is breathing new life into the area, just like it did in 1868. Second, the Sears Building is in the process of becoming reborn as a multimillion-dollar residential and retail development. And third, the greater portion of the avenue and the surrounding historic neighborhoods is continuing to become gentrified. Once again, the old Ponce de Leon Springs site, which spurred the formation of Ponce de Leon Avenue, continues to mirror the development of Ponce de Leon Avenue and the city of Atlanta—a modern society using new techniques to save the architectural treasures of the past and create a green future for its citizens.

BIBLIOGRAPHY

PERIODICALS

Atlanta Constitution
Atlanta Daily Sun
Atlanta Georgian
Atlanta Journal
Atlanta Journal-Constitution
Atlantian
Sunny South
Weekly Constitution

OTHER SOURCES

AM 1690. "Sidewalk Radio: The Clermont Hotel." October 4, 2010.
———. "Sidewalk Radio: Freedom Park." August 18, 2011.
American Architecture and Building News 14, no. 408 (July–December 1883): 191.
Ancestry.com.
Atlanta Building Permits, Atlanta History Center.
Atlanta City Directories, Atlanta History Center.
Atlanta Preservation Center. "2011 Phoenix Flies: Fox Guided Tour; Ponce de Leon Apartment Tour; Stonehenge Mansion and Sanctuary Tour."
Atlanta Urban Design Commission. *City of Atlanta Online*. www.atlantaga.gov/government/urbandesign.
———. "Ponce de Leon Shopping Plaza." *Atlanta Historic Resources Workbook* (1981): 123.

Boylston, Elise Reid. *Atlanta: Its Lore, Legends, and Laughter*. Doraville, GA: Foote and Davies, 1968.

Burns, Rebecca. *Rage in the Gate City: The Story of the 1906 Race Riot*. Cincinnati, OH: Emmis Books, 2006.

Candler, Charles Howard. *Asa Griggs Candler*. Atlanta, GA: Foote and Davies, 1950.

Carson, O.E. *The Trolley Titans*. Glendale, CA: Interurban Press, 1981.

Carter Center News (Fall 1990): 18.

City of Atlanta 7th Grade Pupils. Atlanta, GA: Tech High School Press, 1921.

Cooper, Walter G. *The Cotton States and International Exposition and South, Illustrated*. Atlanta, GA: Illustrator Company, 1896.

———. *The History of Fulton County*. Atlanta, GA: W.W. Brown, 1934.

Craig, Robert M. *Atlanta Architecture: Art Deco to Modern Classic 1929–1959*. Gretna, LA: Pelican Publishing Company, 1995.

Crater, Paul. *Baseball in Atlanta*. Charleston, SC: Arcadia Publishing, 2007.

Druid Hills United Methodist Church. www.druidhillsumc.org/History.html.

Edge, Sarah Simms. *Joel Hurt and the Development of Atlanta*. Atlanta, GA: Atlanta Historical Society, 1955.

Ferrell, John. *Mary Mac's Tea Room: 65 Years of Recipes from Atlanta's Favorite Dining Room*. Kansas City, MO: Andrews McMeel Publishing, 2010.

Fox Theatre (Atlanta) Scrapbook. foxtheatreatlantascrapbook.blogspot.com/2010/07/chapter-23-architect-controversy.html.

Freeman, David B. *Carved in Stone: The History of Stone Mountain*. Macon, GA: Mercer University Press, 1997.

Fulton County Deed Records.

Galloway, Tammy Harden. *The Inman Family*. Macon, GA: Mercer University Press, 2002.

Garrett, Franklin M. *Atlanta and Environs: A Chronicle of Its People and Events*. Athens: University of Georgia Press, 1954.

Gatins, Joseph. *We Were Dancing on a Volcano*. LaVergne, TN: Glade Press, 2009.

Goldstein, Anna. "A Historic Stimulus: The Business of Preservation." *The Rambler* 36, no 3 (Summer 2009): 4–6.

Goodson, Steve. *Highbrows, Hillbillies and Hellfire: Public Entertainment in Atlanta 1880–1930*. Athens: University of Georgia Press, 2002.

Gourney, Isabelle. *AIA Guide to the Architecture of Atlanta*. Athens: University of Georgia Press, 1993.

Hancock, Jerry R., Jr. "Dixie Progress: Sears, Roebuck and Co. and How It Became an Icon in Southern Culture." Master's thesis, Georgia State University, 2008.

Hartle, Robert, Jr. *Atlanta's Druid Hills: A Brief History*. Charleston, SC: The History Press, 2008.

Hatfield, Ben F., et al. *Grace at the Cross: A History of Grace United Methodist Church*. Atlanta, GA, 1996.

Henry Ford Biography. www.biography.com/people/henry-ford-9298747.

Hobson-Pope, Karri, and Lola Carlisle. *Images of America: Virginia-Highland*. Charleston, SC: Arcadia Publishing, 2011.

Ivy Hall: SCAD Writing Center. www.artofrestoration.org/ivyhall/ivyhall.cfm.

Jones, Tommy, and Bamby Ray. "Midtown History." preservemidtownatlanta. org/MidtownHistory.html.

Kaemmerlen, Cathy J. *The Historic Oakland Cemetery of Atlanta: Speaking Stones*. Charleston, SC: The History Press, 2007.

King Plow Arts Center. www.artery.org/KingPlow.htm.

Kuhn, Clifford M., Harlon E. Joye and E. Bernard West. *Living Atlanta: An Oral History of the City 1914–1948*. Athens: University of Georgia Press, 1990.

Lyon, Elizabeth A. *Atlanta Architecture: The Victorian Heritage 1837–1918*. Atlanta, GA: Atlanta Historical Society, 1986.

Martin, Thomas H. *Atlanta and Its Builders*. Boston: Century Memorial Publishing Co., 1902.

McElreath, Walter. *Walter McElreath: An Autobiography*. Macon, GA: Mercer University Press, 1984.

Memoirs of Georgia. Atlanta, GA: Southern Historical Association, 1895.

Mitchell, George. *Ponce de Leon: An Intimate Portrait of Atlanta's Most Famous Avenue*. Atlanta, GA: Argonne Books, 1982.

National Register of Historic Places. Registration form for Virginia-Highland.

New Georgia Encyclopedia. www.georgiaencyclopedia.org.

Olmsted Linear Park Alliance. www.atlantaolmstedpark.org/index.htm.

Open Door Community. opendoorcommunity.org.

Paideia School. www.paideiaschool.org/about_us/history.aspx.

Paideia School, Peter & Kelly's Class. *Patches and Squares of Ponce de Leon*. Atlanta, GA, 1985.

Ponce Condominium. www.poncecondo.com.

PRWeb. "U.S. Rep. John Lewis' Lifetime Commitment to Civil Rights Honored with Public Sculpture." www.prweb.com/releases/2005/09/ prweb282956.htm.

Reagan, Alice E. *H.I. Kimball, Entrepreneur*. Atlanta, GA: Cherokee Publishing Company, 1983.

Roberts, Kathy. *The Fabulous Fox Theatre: The History of an Atlanta Icon*. Atlanta, GA: Atlanta Metropolitan Publishing, 2002.

Rosslyn Apartment, Atlanta. *The Valve World* (January 1914): 156.

Rybczynski, Witold. *A Clearing in the Distance: Frederick Law Olmsted and America in the Nineteenth Century*. New York: Scribner, 1999.

Sanborn Fire Insurance Maps.

Sawyer, Elizabeth, and Jane Foster Mathews. *The Old in New Atlanta*. Atlanta, GA: JEMS Publications, 1976.

Severance, Margaret. *Official Guide to Atlanta: Including Information of the Cotton States and International Exposition*. Atlanta, GA: Foote and Davies Co., 1895.

Shavin, Norman. *Atlanta: Triumph of a People*. Atlanta, GA: Capricorn Corporation, 1982.

———. *Whatever Became of Atlanta?* Atlanta, GA: Capricorn Corporation, 1984.

Shaw, Harry, and Jeanne Osborne Shaw. *They Continued Steadfastly: A History of Druid Hills Baptist Church*. Atlanta, GA: Bennett Brothers Printing Company, 1987.

Shearer, Diane J. "Blind Willie McTell's Georgia Journey." *Georgia Backroads* 10 (Autumn 2011): 26–30.

Shingleton, Royce. *Richard Peters: Champion of the New South*. Macon, GA: Mercer University Press, 1985.

Smith, John Robert. "The Day of Atlanta's Big Fire." *Atlanta Historical Journal* 24 (Fall 1980): 58–66.

Standard Club. standardclub.memberstatements.com/tour/tours. cfm?tourid=54996.

St. John Chrysostom Melkite Catholic Church. "Mansion to Church." www. stjohnmelkite.org/candler.html.

St. Paul's Presbyterian. www.stpaulsatlanta.com/the-abbey.

Temples of the Church of Jesus Christ of Latter-Day Saints. www. ldschurchtemples.com/atlanta.

Toton, Sarah. "Vale of Amusements: Modernity, Technology, and Atlanta's Ponce de Leon Park, 1870–1920." *Southern Spaces*, January 15, 2008. southernspaces.org/2008/vale-amusements-modernity-technology-and-atlantas-ponce-de-leon-park-1870-1920.

United States Federal Census Records.

Weaver, Douglas C. *Second to None: A History of Second-Ponce de Leon Baptist Church*. Nashville, TN: Fields Publishing, 2004.

Westminster Presbyterian Church. "History of Westminster." www. westminster-pca.org/about.html.

Westminster Schools. www.westminster.net/academics/libraries/archives/collections/north-avenue-presbyterian-school/index.aspx.

Williford, William Bailey. *Peachtree Street, Atlanta*. Athens: University of Georgia Press, 1962.

INDEX

INDEX

ABOUT THE AUTHOR

Atlanta native Sharon Foster Jones, a former divorce lawyer, has found her true calling in researching and gathering local history. She lives in Atlanta's historic Inman Park with her husband, three sons, two Shetland sheepdogs, a once-feral cat and a turtle that won't die. This is the third Atlanta history book she has written.